Win

D0296954

C016112822

How to Think Like
da Vinci

By the same author:

How to Think Like Sherlock
How to Think Like Steve Jobs
How to Think Like Mandela
How to Think Like Einstein
How to Think Like Churchill
How to Think Like Bill Gates

How to Think Like
da Vinci

DANIEL SMITH

Michael O'Mara Books Limited

For Rosie and Lottie

First published in Great Britain in 2015 by
Michael O'Mara Books Limited
9 Lion Yard
Tremadoc Road
London SW4 7NQ

A CIP catalogue record for this book is available from the British Library.

Papers used by Michael O'Mara Books Limited are natural, recyclable
products made from wood grown in sustainable forests. The manufacturing
processes conform to the environmental regulations of the country of origin.

ISBN: 978-1-78243-458-0 in hardback print format
ISBN: 978-1-78243-467-2 in paperback print format
ISBN: 978-1-78243-459-7 in e-book format

1 3 5 7 9 10 8 6 4 2

Designed and typeset by Envy Design Ltd

Printed and bound by CPI Group (UK) Ltd, Croydon, CR0 4YY

www.mombooks.com

Contents

Introduction

'He was like a man who awoke too early in the
darkness while everyone else was asleep.'

D M I T R Y M E R E Z H K O V S K Y , 1 9 0 1

In the five and a half centuries or so since his birth, Leonardo da Vinci has become a cypher. He is perhaps the best-known artist of all time. Ask someone without the vaguest interest in fine art to name an artist and there is a fair chance that if they don't mention Picasso, it will be da Vinci instead. His *Mona Lisa* is the single most recognizable picture in the world, not least because it has so often been parodied. Student walls across the globe have for generations been adorned with images of that enigmatically smiling woman embellished with thick-rimmed spectacles, giving a peace sign or smoking a joint.

Da Vinci has also become a symbol of genius. Whether it is useful to see him in these terms is debatable, for the concept of genius is a fluid one. What makes a genius? Extreme intellect? Uncanny natural abilities? Perhaps even some kind of divinely appointed superhuman power? The word itself tends to alienate the subject of the term from the world at large. Da Vinci may have had the characteristics of genius, but to see him simply in those terms is to render him distant, unobtainable, unearthly. It is virtually impossible to see da Vinci the genius as one of us.

It is also to do this extraordinarily complex and multi-

layered man a disservice. Certainly da Vinci was blessed with extraordinary gifts across a range of fields. It is, as some academics have suggested, quite possible that he possessed a brain physiologically different to the vast majority of us. His ability to master disparate disciplines with such apparent ease might, for instance, indicate extremely rare rates of development in both the left and right spheres of the brain. It may also have been wired in such a way that he could see fleeting actions almost as if in slow motion. But for all this, da Vinci also faced many of the challenges with which life confronts the rest of us, along with a few more besides. Crucially, he was familiar with failure and believed that time was his constant enemy, the clock running out on several of his most ambitious projects.

His personal life was somewhat complicated too, to say the least. The background into which he was born gave little hint that he was destined for greatness. Emotionally, he never quite recovered from the lack of a stable parental upbringing, instead being raised by his extended family before being launched into professional life when no more than a young teen. His adult relationships, meanwhile, were impacted by his assumed homosexuality.

Whatever his personal demons, his creative output is unmatched in history. His known artworks would mark him out as one of the most extraordinary people who ever lived, but they are just a part of a much bigger landscape. The brilliant painter, sculptor and musician was also an outstanding scientist, who famously designed flying machines centuries ahead of their time and documented

the human anatomy more thoroughly than anyone before him. He was a talented mathematician, a quite spectacular engineer and architect, an inventor who came up with everything from kitchen gadgets to prototype submarines, a botanist, designer, cartographer, philosopher ... we could go on.

Along with relatively few completed artworks, he left thousands of pages of detailed notes, which provide us with perhaps our best source to investigate his mind and personality. Such was his fame even in his own lifetime that his life was well documented by contemporary biographers, most famously Giorgio Vasari (who described da Vinci as 'a man of regal spirit and tremendous breadth of mind').

Using these sources – and with the benefit of centuries of subsequent scholarship – da Vinci the man can be excavated from the myths that have built around his name. He proves even more interesting than his legend would suggest. In the pages that follow, I hope to take you on a journey through his complex character, looking at what made him great, but also at the flaws, failings and frailties that render him recognizably human.

Liana Bortolon wrote in *The Life, Times and Art of Leonardo*:

Because of the multiplicity of interests that spurred him to pursue every field of knowledge ... Leonardo can be considered, quite rightly, to have been the universal genius par excellence, and with all the disquieting overtones inherent in that term. Man is

as uncomfortable today, faced with a genius, as he was in the sixteenth century. Five centuries have passed, yet we still view Leonardo with awe.

But the veil of genius has shrouded him for too long. To rediscover Leonardo da Vinci the man is a rich and rewarding experience.

Extant Works

Below is a list of the existing paintings on which da Vinci is generally accepted as the major, or sole, contributor (along with their suspected dates of production and current location). Please note, only one example of his sculpture survives, a small beeswax equestrian model – a study for a much larger work – made in 1508 and now privately owned.

- *Portrait of Ginevra de' Benci* (*c.* 1474, National Gallery, Washington, D.C., USA)
- *The Annunciation* (1472–5, Galleria degli Uffizi, Florence, Italy)
- *The Annunciation* (*c.* 1478, Musée de Louvre, Paris, France)
- *Madonna of the Carnation* (1478–80, Alte Pinakothek, Munich, Germany)
- *Benois Madonna* (*c.* 1478, Hermitage, St Petersburg, Russia)
- *Saint Jerome* (1480–82, Pinacoteca Vaticana, Vatican City, Italy)

Extant Works

- *The Adoration of the Magi* (1481, Galleria degli Uffizi, Florence, Italy)
- *The Virgin of the Rocks* (1483–6, Musée de Louvre, Paris, France)
- *Portrait of a Musician* (*c.* 1485, Pinacoteca Ambrosiana, Milan, Italy)
- *Lady with an Ermine* (1488–90, Czartoryski Museum, Krakow, Poland)
- *The Virgin of the Rocks* (1491–1508, National Gallery, London, UK)
- *Portrait of a Lady* (*c.* 1495, Musée de Louvre, Paris, France)
- *The Last Supper* (1495–8, Refectory of Santa Maria delle Grazie, Milan, Italy)
- *Sala delle Asse* (1497–8, Castello Sforzesco, Milan, Italy)
- *Portrait of Isabella d'Este* (1499–1500, Musée de Louvre, Paris, France)
- *The Virgin and Child with Saint Anne and Saint John the Baptist* (*c.* 1500 or *c.* 1506–8, National Gallery, London, UK)
- *Mona Lisa* (1503–*c.* 1507, Musée de Louvre, Paris, France)
- *Salvator Mundi* (*c.* 1506–13, private collection)
- *Head of a Young Woman* (*c.* 1508, Galleria Nazionale, Parma, Italy)
- *The Virgin and Child with Saint Anne* (1510–13, Musée de Louvre, Paris, France)
- *Saint John the Baptist* (*c.* 1505–7 or 1513–16, Musée de Louvre, Paris, France)

- *Bacchus* (Saint John) (1513–15, Musée de Louvre, Paris, France)

Landmarks in a Remarkable Life

1452 Leonardo is born on 15 April in the vicinity of Vinci, not far from the Italian city state of Florence. He is the illegitimate son of a local notary, Piero, and a young girl of lowly social standing.

c. mid-1460s Leonardo is apprenticed to a respected Florentine artist, Andrea del Verrocchio. He stays with Verrocchio for thirteen years.

1469 Lorenzo de' Medici ('the Magnificent') comes to power in Florence. A leading supporter of the Renaissance, he becomes one of da Vinci's most important patrons.

c. 1470 Da Vinci contributes elements to Verrocchio's *Tobias and the Angel*.

1472 Da Vinci is accepted into Florence's Painters' Guild. Sandro Botticelli joins in the same year.

1473 Da Vinci produces his first drawing known to have survived to the present day – a landscape on the Feast of Santa Maria delle Neve. He also begins work on the *Madonna of the Carnation*, considered among his earliest independent paintings.

1474 He completes his first known portrait, of Ginevra de' Benci.

1475 Michelangelo Buonarroti, da Vinci's great professional rival, is born in the Republic of Florence. Meanwhile, da Vinci is a major contributor (probably in collaboration with Verrocchio) to the painting *The Annunciation*.

1476 Da Vinci is publicly accused of homosexual acts, but the case is quickly dismissed by the courts.

1481 Da Vinci is commissioned by the monastery of San Donato a Scopeto to paint *The Adoration of the Magi*, a work he never completes but which is nonetheless considered a masterpiece.

1482 He relocates to Milan, where he works primarily for the duke, Ludovico Sforza.

1483 Da Vinci is commissioned by the Confraternity of the Immaculate Conception to paint *The*

Virgin of the Rocks. Meanwhile, Raphael is born in Urbino and is destined to join da Vinci and Michelangelo among the three great names of Renaissance art.

1485 Milan is struck by plague. Around this time, da Vinci is busying himself with designs for flying machines.

c. 1487 Da Vinci begins his anatomical studies in earnest.

1488 Verrocchio dies in Venice.

1490 Da Vinci starts work on the long-discussed creation of a giant bronze horse sculpture for Sforza. Salai joins da Vinci's household.

1492 Lorenzo de' Medici dies in Florence, marking the end of the city's Renaissance Golden Age. Meanwhile, Christopher Columbus discovers the New World.

1493 Da Vinci completes a large-scale clay model of the Sforza horse (*Gran Cavallo*).

1495 Da Vinci begins painting *The Last Supper* in the refectory of the Milanese church of Santa Maria delle Grazie.

1496 He provides illustrations for a treatise on mathematics, *De divina proportione*, by Fra Luca Pacioli.

1498 Da Vinci decorates the interior of the Sala delle Asse, a room in Sforza's Milanese castle. He is also actively designing flying machines.

1499 Milan falls to an invading French army. Da Vinci leaves within a few months of the takeover.

1500 He travels first to Mantua, where he paints a portrait of Isabelle d'Este, before returning to Florence. There he paints *The Virgin and Child with Saint Anne*.

1502 Da Vinci enters the employment of Cesare Borgia, Duke of Valentinois, as a military engineer. In this role he travels around the Romagna region with the duke's forces. He is also introduced to Niccolò Machiavelli, a Florentine diplomat who will find lasting fame as author of the political treatise, *The Prince*.

1503 Having returned to Florence, da Vinci begins work on what is the largest physical commission he ever receives, to paint the Battle of Anghiari in the council chamber of the Palazzo Vecchio. Michelangelo was employed to paint another

battle scene on the opposite wall. Da Vinci also devised a plan to divert the Arno River in order to starve Florence's nearby rival, Pisa, of a navigable waterway. The project fails. He also begins work on *Mona Lisa*.

1504 Ser Piero, Leonardo's father, dies, leaving nothing to his illegitimate progeny.

1505 Da Vinci abandons work on *The Battle of Anghiari*, which is already deteriorating after his experiments with fresco painting techniques fail.

1506 Charles d'Amboise, the French governor of Milan, requests da Vinci's presence in the city.

1507 Da Vinci becomes painter and engineer to the French king, Louis XII. He is working on a second version of *The Virgin of the Rocks* and employs Francesco Melzi as his secretary. Leonardo's uncle, Francesco, dies, leaving his nephew a considerable estate in contravention of an earlier agreement with Ser Piero, thus prompting several years of litigation.

1508 Michelangelo starts to paint the Sistine Chapel.

1511 Giorgio Vasari – the great biographer of the Renaissance age and one of the most important

primary sources of information on da Vinci's life – is born.

1513 Da Vinci moves to Rome, takes up residence in the Vatican and begins studies into the properties of mirrors. He is also likely to have produced the famous Turin self-portrait around this time.

c. 1515 Da Vinci delights Francis I, the newly crowned king of France, with a mechanical lion.

1516 Da Vinci enters the court of Francis I, living in relative luxury at Amboise in France.

1519 Leonardo da Vinci dies on 2 May at Cloux, Amboise.

Pull Yourself Up by Your Bootstraps

'Lying in a feather bed will not bring you fame,
nor laying beneath the quilt ...'

DANTE ALIGHIERI, QUOTED BY LEONARDO
DA VINCI IN HIS NOTEBOOKS

If you had to predict the circumstances that would birth perhaps the single greatest mind in human history, it is unlikely you would have alighted upon Leonardo da Vinci's peculiar entry into the world. Here was a boy not born into a great lineage of noted talents and intellects, nor even into a family determined to hothouse their little boy towards greatness. In fact, it looked rather as if Leonardo was destined for a life of struggle, his prospects and opportunities actively restricted by the conditions of his birth.

Da Vinci was born deep in Italy's Tuscan countryside on 15 April 1452. At that time, Italy was not the unified nation we know today, but was composed of a series of powerful 'city states'. His birthplace was not far from Florence, the focal point of the Renaissance that was then sweeping across Europe. The Renaissance was a cultural 'rebirth' (a literal translation from the French) that began roughly in the mid-fourteenth century and looked to classical Greek and Roman culture as the inspiration for an astonishing creative flowering that stretched from northern Europe right down to Italy. Yet while da Vinci would emerge as among the two or three most significant figures of the Renaissance, he was certainly not born into it. Instead, he

grew up as the illegitimate son of a cold and distant father and an unmarried girl of lowly social standing.

His father, Piero Fruosino di Antonio da Vinci, came from a well-to-do family who, over several generations, had made their names as notaries, providing a good deal of the paperwork that underpinned Florence's burgeoning commercial health (which in turn freed up money for its generous patronage of the arts). The 'da Vinci' name denotes that the family were 'of the town of Vinci', although we cannot be sure of Leonardo's exact place of birth. Some hold he was actually born in a tiny hamlet called Anchiano, a couple of miles outside of Vinci.

It has often been said that the name 'Vinci' is rooted in the Latin word *vincere*, meaning *to conquer*. It is a neat suggestion for those who wish to portray Leonardo as a sort of cultural warrior forging a triumphant path through life. However, the name actually comes from the old Italian word for *osier*, a type of willow that was traditionally used for basket weaving in the area. Sure, Leonardo was born within a short distance of the greatest hub of the Renaissance, but he grew up in a relative backwater, many of whose residents never made it beyond the town boundaries.

Furthermore, Leonardo's legal status as a bastard meant that he was barred from attending university or joining the professions. By the quirk of fate that saw him born to unmarried parents, Leonardo was instantly denied hope of passage into any number of well-paid careers for which his remarkable talents would undoubtedly have rendered him well suited.

Nor did he receive a great deal of emotional support from

his parents. A rather grand christening – which included ten godparents in attendance – might suggest that his illegitimacy didn't initially count against him. But Ser Piero (the 'Ser' denotes his gentlemanly standing) was an ambitious man and was soon looking to make a marriage that would assist his social advancement. Meanwhile, Leonardo's mother, Caterina – who was about twenty-five years old when she gave birth – may have come from a family with a long history (the question remains very much up for debate) but could boast little in the way of wealth. Although biographers writing close to the time could not agree on her occupation, several suggested she was a simple serving girl.

We know little of the relationship between Ser Piero and Caterina, and it is quite possible they harboured a genuine love. Intriguingly, when in his fifties da Vinci wrote, 'The man who has intercourse aggressively and uneasily will produce children who are irritable and untrustworthy; but if the intercourse is done with great love and desire on both sides, then the child will be of great intellect, and witty, lively and lovable.' By general consensus, da Vinci was himself of 'great intellect, and witty, lively and lovable', so perhaps he was hinting that his own parents were a love match. Regardless, there seems to have been no realistic prospect of them marrying.

Within a year, both were wedded to other people: he to the sixteen-year-old daughter of another rich notary and she to a furnace worker by the name of Accattabriga. Leonardo probably lived with his mother and stepfather in Campo Zeppi, an area a little west of Vinci in which the Accattabrigas had family interests.

Ser Piero was little more than an absent father over the next few years, although Leonardo was shown care and affection by a paternal uncle, Francesco, who had remained in Vinci to work in agriculture and viticulture. Again, we cannot be sure how well Leonardo was treated by his stepfather, but in years to come Leonardo wrote one of his slightly mysterious prophecies (which we should perhaps think of rather as a mixture of 'words of wisdom' and 'riddles' than 'predictions') thus: 'Fathers and Mothers will be seen to take much more delight in their step-children than in their own children.' He was referring in the prophecy to trees that nourish grafted shoots, but one wonders if there wasn't a deeper truth contained therein.

Within a year or two of his birth, Leonardo's unstable upbringing took another turn when he was put under the care of his father's parents, who were by then quite elderly and neither physically nor emotionally equipped to tend a young and restless charge. So it fell to kindly Uncle Francesco to look after the boy, a job he did with dedication and an open heart. It was, we must suspect, the making of Leonardo, who at last found himself wanted and cherished. Nonetheless, it must have demanded vast reserves of self-belief and determination from Leonardo to raise himself up from these unpromising beginnings to become one of the most significant figures who has ever lived. At the same time, we may well conjecture that the rejection he experienced as a young child was a driving force behind his desire to make an indelible mark on the world and win the approval and acclaim of the wider society.

Commune with
Nature

'Those who take for their standard anything
but Nature, the mistress of all masters,
weary themselves in vain.'
LEONARDO DA VINCI, WRITING
IN HIS NOTEBOOKS

Da Vinci had an ingrained passion for the natural world that not only inspired much of his greatest work but also provided the basis for his life philosophy. He believed that nature is so perfect in all respects – aesthetically, mechanically and as a balanced microcosm – that he was convinced humans could do no better than aspire to reflect it in art and replicate it in science. Take his thoughts on technological innovation:

> Though human ingenuity may make various inventions which, by the help of various machines, answer to the same end, it will never devise any inventions more beautiful, nor more simple, nor more to the purpose than Nature does; because in her inventions nothing is wanting, and nothing is superfluous.

His love affair with the natural world began in the hillsides of Vinci, and specifically in the company of Francesco as the two spent days tending crops, nurturing orchards and olive groves, and looking after the vineyards. The young Leonardo had an enquiring mind and was keen

to learn about the natural world that provided such an inspiring backdrop for his early upbringing. That great documenter of Renaissance personalities, Giorgio Vasari, wrote that da Vinci 'investigated the properties of plants and then observed the motion of the heavens, the path of the moon, and the course of the sun'.

Our modern world long ago disconnected most of us from those natural elements that support us but, for Leonardo, the links were obvious and omnipresent. The olive, for instance, was a staple crop on his uncle's land and served not only as a foodstuff but also gave oil that served as a lubricant, as a medicine and as fuel for lamps. Indeed, the olive harvest would make an appearance years later in another of his prophecies in which he noted, 'There will pour down from the sky that which gives us food and light.'

Of course, da Vinci's appreciation of the natural landscape was most fully realized in his paintings. From *The Annunciation* (1478, da Vinci's first major solo work) through his various depictions of the *Virgin and Child* and in his landmark portraits (including, of course, *Mona Lisa*), landscape serves not merely as a backdrop to the central characters but as integral pieces establishing the mood and emotion of the pictures. He paints living landscapes, more often than not recalling the Tuscan hillsides of his childhood. It is not too far to say that da Vinci was the first great landscape artist, in an era when artistic works were almost exclusively focused on depicting human or divine figures. In fact, da Vinci's earliest dated drawing, made in 1473 and now to be seen at the Uffizi in Florence, was

of a landscape near Vinci. Kenneth Clark, writing in the twentieth century, said:

> To Leonardo a landscape, like a human being, was part of a vast machine, to be understood part by part and, if possible, in the whole. Rocks were not simply decorative silhouettes. They were part of the earth's bones, with an anatomy of their own, caused by some remote seismic upheaval. Clouds were not random curls of the brush, drawn by some celestial artist, but were the congregation of tiny drops formed from the evaporation of the sea, and soon would pour back their rain into the rivers.

The countryside also lives within his pages of notes, in sketches, studies and verbal observations. He referenced dozens of species of flora in those pages and advised his fellow artists to find their inspiration in the natural environment: 'Quit your home in town, and leave your family and friends, and go over the mountains and valleys into the country.'

His naturalist credentials extended to a genuine compassion for the animal world. He displayed a concern for animal rights far ahead of his time. As Vasari related:

> He took an especial delight in animals of all sorts, which he treated with wonderful love and patience. For instance, when he was passing the places where they sold birds, he would often take them out of their cages with his hand, and having paid whatever

price was asked by the seller, he would let them fly away, giving them back their lost liberty.

It was a view confirmed by his long-time friend and companion, Tommaso Masini (also known as Zoroastro): 'He would not kill a flea for any reason whatever; he preferred to dress in linen so as not to wear something dead.'

At times, da Vinci seemed almost to have greater love for the animal world than for human society, an attitude that perhaps reflected his early, disappointing experience of human relationships. 'Man has great power of speech,' he would write as an adult, 'but what he says is mostly vain and false; animals have little, but what they say is useful and true.' As if to prove the notion, he wrote a collection of fables while he was living in Milan in around 1490, which were full of animals able to speak and who used their skill to dispense wisdom. While the origins of these fables is not wholly clear, the evidence seems to point to them being original ideas from da Vinci himself rather than reworkings of existing folk tales. The stories also express repulsion at animal suffering. This was doubtless a genuinely held conviction, despite the fact that Leonardo was prepared to undertake animal dissections in the interests of science.

His love for nature that bloomed in the child who trod the land around Vinci remained with him throughout his life, even as his career saw him spend most of his adulthood dwelling in bustling cities. He was always a keen walker and a skilled equestrian, which gave him opportunity to

'get away from it all' now and again. Indeed, he kept a stable of horses into his old age and those majestic beasts themselves inspired some of his most beautiful drawings, as well as his most ambitious sculptural projects.

It is also telling that da Vinci – who never truly established a home for himself as an adult – entered the property market for the first time in his own right when he bought a plot of land with a vineyard upon it in 1497. Here he indulged his love of gardening, a pastime that captured his imagination over many years. It was as if home for him was less a bricks-and-mortar structure than a sense of being at one with the land and his beloved natural environment.

WATER POWER

'Write first of all water, in each of its motions; then describe all of its beds and the substances therein.'

LEONARDO DA VINCI'S NOTE ON A
PROPOSED TREATISE ON WATER

For all that da Vinci loved the rugged terrain of the Tuscan countryside, delighted in flowers and plants, and felt a bond with animals that he often lacked with humans, he also respected nature as a powerful and unpredictable force – a fact reflected in an ongoing desire to explore in particular the nature of water both in terms of science and aesthetics.

So, for instance, we have the quote on the previous page, suggestive of da Vinci's desire to fully analyse every aspect of the element. In the Codex Leicester (a notebook now in the possession of IT magnate Bill Gates), da Vinci made copious observations concerned with geophysics and water, creating a work that is as much a philosophical rumination as a traditional scientific text.

WATER BABY

Da Vinci's obsession with water probably began when he was still a young child. When he was around four he witnessed the first of two devastating natural phenomena that marked his early years. A hurricane swept across Tuscany, wreaking havoc on land and water and leaving thousands dead. Then, when he was ten, the River Arno broke its banks, flooding Florence. That majestic icon of civilization had been rendered powerless in the face of the swelling waters.

He made many attempts over his career to capture the majesty of water in its numerous guises, both in words and in visual media – from the landscapes in works such as *The Virgin of the Rocks* to quickly executed sketches in his notebooks. He also left us this elegant description of

the waters around Cyprus, although there is no evidence he ever travelled to the area himself:

From the shore of the Southern coast of Cilicia may be seen to the South the beautiful island of Cyprus, which was the realm of the goddess Venus, and many navigators, being attracted by her beauty, had their ships and rigging broken amidst the reefs, surrounded by the whirling waters. Here the beauty of delightful hills tempts wandering mariners to refresh themselves amidst their flowery verdure, where the winds are tempered and fill the island and the surrounding seas with fragrant odours. Ah! how many a ship has here been sunk. Ah! how many a vessel broken on these rocks.

In the early 1490s, he composed instructions on how to represent a tempest in paint:

You must first show the clouds scattered and torn, and flying with the wind, mixed with clouds of sand blown up from the seashore, and boughs and leaves swept along and scattered with other light objects which are flying around ... while the wind flings sea-spray around and the stormy air takes on the look of a dense and smothering mist.

He was still striving to perfect the representation of tempests into his old age, and in his sixties produced illustrated texts related to the biblical Deluge. Vasari,

meanwhile, wrote of a drawing of the sea god Neptune, in which da Vinci showed 'the restless ocean and Neptune's chariot drawn by sea-horses, and the sprites, the sea-monsters, and the winds, along with some very beautiful heads of sea-gods'.

Da Vinci appreciated nature as a raw and elemental force, with water representing that aspect over which man arguably has least power and command. His fasc -ination with water is a reflection not only of his awed admiration for the natural world but also his desire to reflect and understand it. With that in mind, it is telling that (as we shall see in due course) he should come to devise some of the most ambitious civil engineering schemes of the age (and even designed an extraordinary diving suit made of leather) aimed at achieving some level of mastery over water.

Seize Your Opportunities

'When Fortune comes, grasp her with a firm
hand – in front, I tell you, for behind she is bald.'

LEONARDO DA VINCI, WRITING
IN HIS NOTEBOOKS

Given that he was anything but born to privilege, it was vital that da Vinci seized his opportunities when they presented themselves. The quote on the previous page, contained in the Codex Atlanticus, shows that he never entirely trusted fortune and recognized she could be a fickle friend. Nonetheless, he rarely let a chance pass him by.

Da Vinci's first big break owed much to the fact that his nascent artistic talent was not easily ignored. He always carried a notebook with him, drawing whatever subject happened to capture his imagination. Although his father gave him little, Leonardo never went short of paper, since a notary always kept a healthy stock of that particular material. Nor did it take an expert eye to see that Leonardo was producing work considerably beyond your average childish daubs. Ser Piero decided to show his son's pictures to an artist friend he had in Florence, Andrea del Verrocchio.

Verrocchio knew a good thing when he saw it and agreed to take Leonardo on as his apprentice. Leonardo, in his early to mid-teens at the time, moved to Florence to live in Verrocchio's studio full-time. Finding himself at the very epicentre of the Renaissance world, the boy

rose to the challenge of establishing himself as a valued member of Verrocchio's circle until, after several years of hard work, he achieved membership of the prestigious Artists' Guild in his own right.

Although da Vinci's skills were regularly in demand, he was not always inundated with profitable commissions as we might expect of someone with such talent. With that in mind, he was content to accept a helping hand every now and again. One such came in 1481 when he received a commission from the well-to-do Augustinian monastery of San Donato at Scopeto to paint an altarpiece, the subject matter of which was to be the adoration of the Magi. Da Vinci was rather down on his luck at the time, undertaking odd jobs in return for firewood and having to ask for advances to cover the cost of basic provisions such as paints, grain and wine. It just so happened that his father was the notary responsible for the financial affairs of the monastery and we may safely assume the Ser Piero encouraged the commission towards his son as a favour.

While the contract with the monks was complicated (involving provision of a property in return for Leonardo paying the wedding dowry of an unrelated woman, among other obscure clauses) and the project an unsatisfying one (he would never deliver a completed work), it gave da Vinci a chance to find his feet again.

He was also a master at seeking out patrons and sensing when it was time to move on. The Medici certainly recognized his clear talent and an anonymous, almost contemporary, manuscript referred to as the Anonimo Gaddiano, claimed da Vinci was a particular favourite of

Lorenzo the Magnificent. However, later historians have concluded that the relationship was perhaps more troubled than that, not least because Lorenzo also adored Michelangelo. Whatever the truth, da Vinci moved to Milan in 1490 when it seemed that there was greater opportunity there.

There is no clearer display of da Vinci's acute opportunism than his scheme to ingratiate himself with Ludovico Sforza, the Duke of Milan. He wrote a letter to the intimidating, warlike Sforza, which served as a detailed curriculum vitae.

Whatever the Duke of Milan wanted, da Vinci effectively said, he would provide. In particular, he offered his services as a military engineer, knowing that Sforza was on the constant lookout for the latest in military innovation. Despite the fact that da Vinci had no proven track record, he emphasized his skills in this field (and, as it turned out, he had them in abundance). And just to be sure of winning the duke's attentions, he also promoted himself as a lyre player of the first order (again, no exaggeration), knowing that Sforza was a great music fan. Sure enough, da Vinci's audacity paid off and before long he was in the pay of the duke.

Some two decades later, when the chips were down in Milan after the French successfully invaded the city, da Vinci returned to Florence as something of a conquering hero. Then it was into the employ of Cesare Borgia (whom he left just a few months before his star began to descend) and, ultimately, the king of France. Da Vinci thus proved throughout the course of his life to have a reliable sixth sense as to where his interests were likely best served at any given time.

LIFE AS AN ARTIST'S APPRENTICE

> 'Many wish to learn how to draw, and enjoy
> drawing, but do not have a true aptitude for
> it. This is shown by their lack of perseverance,
> like boys who draw everything in a hurry, never
> finishing or shadowing.'
>
> **LEONARDO DA VINCI**

The life of an artist's apprentice in Renaissance Italy was not an easy one, but those with the aptitude and commitment could receive an education in all the broad skills an artist needed from some of the greatest masters of the age.

When a young boy (always boys, and usually aged between ten and fifteen) entered into an apprenticeship, he was committing himself to several years of toil. In return, he received his bed and board and a little pocket money – as well as the benefit of his master's hard-earned wisdom and experience. The hours were long and the work could be arduous, but if the master looked upon his apprentice with a little kindness, it was not such a bad life. And for a boy like Leonardo, whose illegitimate birth ruled out so many other professional options, it offered the chance of a long and fulfilling career.

Verrocchio was a good master to have. He was a big name on the art scene and was undeniably talented, particularly

as a draughtsman (an expert in drawing). Indeed, he may be considered among the greatest – if not the greatest – draughtsman of the age. Although contemporary biographers suggested Leonardo was not necessarily his favourite pupil, the two got on well enough, resulting in Leonardo remaining part of the Verrocchio studio for no less than thirteen years, long after he could have struck out on his own, if he desired.

To begin with, da Vinci would have been a general factotum within the studio (or *bottega*). As well as fetching and carrying as the master required, he was expected to keep the premises swept and clean and would have been schooled in how to mix paints (egg-based tempera paints were the order of the day, although da Vinci was destined to become one of the early innovators of oils in Italy), make brushes and prepare the wooden panels on which paintings were done (a process involving boiling boards and covering them first in a layer of glue and then a coat of fine plaster called *gesso*). Ironically, some of da Vinci's own works would be compromised when he attempted to shortcut the rules regarding the materials he used. His motivations for doing so ranged from economic (he was known to use cheap, substandard board on occasion) and for convenience (see his disastrous adaptations to the accepted rules of fresco-painting on both *The Last Supper* and *The Battle of Anghiari*).

The training of an apprentice was a formal business and one Verrocchio took very seriously. Not only was his professional reputation at stake, a good apprentice played an invaluable role in the efficient running of a

studio. Verrocchio began by teaching his pupils the rudiments of drawing and draughtsmanship. Leonardo likely had his first formal education in perspective and texture under him, and would have also undertaken life-drawing sessions.

It was perhaps years before the average apprentice was let loose with a paintbrush, not least because the materials involved were very expensive – from the pigments used to give colour to paints to the poplar, pear and walnut wood boards popularly painted upon. As well as painting on to wood, pupils were also instructed in fresco painting (an area in which da Vinci perhaps could have benefitted from extra classes!). In addition, they could expect to receive schooling in clay modelling and pottery, sculpture, gold and silver work, and architecture.

If all that were not enough, there was a move during the Renaissance towards providing apprentices with instruction across the 'liberal arts'. Essentially, the pupil was to receive the kind of broad classical education that was not so far removed from that being taught in the great universities of the day. It was an initiative that had been championed by Lorenzo Ghiberti (1378–1455) – a man perhaps best remembered for creating the monumental doors of Florence's baptistery – and demanded pupils study disciplines including anatomy, arithmetic, astronomy, geometry, grammar, history, medicine and philosophy. With artists casually passing through day-to-day, the *bottega* thus became a talking shop and an arena for intellectual exchange. Indeed, the apprentices of Renaissance Florence received nothing less than a schooling in the University of Life.

Leonardo's first major contribution to a significant work of the Verrocchio studio came around 1470, when he painted a cat and a dog for a piece called *Tobias and the Angel* (which may be seen today at London's National Gallery). It is also likely that he gave Tobias his tumbling, curly locks – a feature that would become something of a da Vinci trademark. He was admitted to the Painters' Guild in 1472 but the first known, major work of his own (*The Annunciation*) dates only to 1478.

It was not until around this time that he set up his own studio. Just as he had paid his dues, so he put his own apprentices through their paces. As Paolo Giovio, a contemporary chronicler, described it, da Vinci would not allow pupils under the age of twenty to go anywhere near a painter's pallet, instead demanding they practise with a lead stylus, study the works of classical artists, and strive to capture the beauty of the natural world and the human form with the simplest lines possible. It was by dint of such hard work, he knew himself, that greatness might be achieved.

Be a Renaissance Man

'Occasionally, in a way that transcends nature, a single person is marvellously endowed by heaven with beauty, grace and talent in such abundance that he leaves other men far behind, all his actions seem inspired, and indeed everything he does clearly comes from God rather than from human art.'

GIORGIO VASARI IN *LIVES OF THE ARTISTS*, 1568

Leonardo da Vinci is often spoken of as the ultimate 'Renaissance Man', but what does that actually mean? In short, it suggests an individual with accomplishments across a broad range of disciplines, including the arts and sciences.

In today's world, most of us are encouraged to become specialists – whether it be brain surgery, accounting or customer service. In the classical world, however, the polymath was king. The greatest minds sought knowledge in every corner of life. There were no clearly defined boundaries that said a philosopher could not be a poet, a mathematician, an astrologer or an anatomist as well. And so it was again during the Renaissance. Europe had recently emerged from its Dark Ages – the term may be controversial but it is hard to argue that the thousand years from the fifth century represent the high-point of European development – and now intellectualism was prized again.

Alongside it came the rise of humanism that emphasized the inherent dignity of humanity and, crucially for the likes of da Vinci, extolled the spirit of the individual. In practice, this meant that where once artists were regarded as tradesman, they were now regarded as creative forces,

the best of whom achieved superstar status. Previously it had hardly mattered if an artist signed a work or not; now it was essential. Even a lesser work by a da Vinci (or a Fra Angelico or Raphael) was attributed an intrinsic worth.

Such was the exciting milieu into which da Vinci was unleashed. And there was no more exciting place to be than Florence, replete with beautiful new buildings and works of art, all funded by the ruling Medici dynasty who loved nothing more than displays of wealth. From ground-breaking architectural projects to staggering artistic commissions and stunning public festivals and spectacles, the Medici were intent on leaving their mark.

The Renaissance was a time for revisiting classical culture and questioning the accepted beliefs of the medieval age. While Christianity and the Catholic Church remained central to European life, there were fundamental challenges to traditional teachings about man and his soul, the workings of the natural world, and Earth's place within the universe. There was political and economic upheaval too, while the great voyages of discovery (Christopher Columbus discovered America when da Vinci was in his fortieth year) brought disparate cultures into contact for the first time. With new horizons opening up, the Renaissance was a time of intoxicating excitement, tempered by great uncertainty. As Charles Nicholl, author of *Leonardo da Vinci: Flights of the Mind*, said of the age, 'If everything is possible, nothing is certain.' Da Vinci, fortunately, had just the credentials to prosper in such circumstances: intelligence, talent, curiosity, ambition and a work ethic.

Nor did he lack role models and inspirations. In terms of art, his predecessors in Florence included Donatello, Fra Angelico, Fra Lippi, Andrea de Castagno and Domenico Veneziano. His own generation counted among their number the likes of Botticelli and Domenico Ghirlandaio, with Michelangelo and Raphael following on shortly afterwards. He was also a great admirer of Leon Battista Alberti (1404–72), whose talents embraced architecture, literature, scholarship, art and design, town planning, philosophy and even athletics. His architectural treatise, *De re aedificatoria*, was one of da Vinci's most prized tomes. Alberti has himself been described as the original Renaissance man and the parallels with da Vinci are striking. Both, for instance, were born illegitimate and both learned how to get on in polite society. As Alberti had it, the cultivated man 'must apply the greatest artistry in three things: walking in the city, riding a horse, and speaking', but must ensure none of these seem 'to be done in an artful way'.

Da Vinci, was doubtless aware he was living through a period of cultural evolution, but did not think of it as 'the Renaissance' – a term that only came into popular usage in the nineteenth century. Yet he emerges as the dominant figure of the period, the multi-talented intellect who excelled across the arts and was visionary both as a theoretical and applied scientist. Da Vinci was at the forefront of that march out of medieval superstition and unchallenged dogma into the brave, new – and bewilderingly uncertain – modern world.

Da Vinci's Philosophy of Painting

'The painter strives and competes with nature.'

LEONARDO DA VINCI, WRITING
IN HIS NOTEBOOKS

Amid a plethora of brilliant artists birthed by the Renaissance, Leonardo da Vinci was arguably the greatest of them all. Certainly, his rivals to that title are limited in number – perhaps only Michelangelo and Raphael came close to having his impact in the arts. So what was it that marked him out as so important?

His painting output was restricted to the traditional subjects of his time – portraiture and religious iconography – but he brought a level of realism and emotional impact to his work that had hitherto never been seen. When one compares the work of da Vinci with pre-Renaissance European art, it is as if he was the product of a huge evolutionary leap. Where figures were once mere stylized ciphers, da Vinci painted 'real' people with 'real' feelings against exquisitely naturalistic backdrops. While the pursuit of realism is most certainly not a prerequisite of great art, its attainment by the first rank of Renaissance artists is perhaps the most formidable achievement in mankind's long cultural development. Not that da Vinci was merely a camera, capturing the reality of the world around him. His work is imbued with meaning, too. In his own words, 'The painter who draws merely by practice and by eye, without

any reason, is like a mirror, which copies everything placed in front of it without being conscious of their existence.'

Clearly, da Vinci took the business of painting very seriously indeed. He was disdainful of those who merely trifled in the discipline. 'Many are they who have a taste and love for drawing,' he noted, 'but no talent ...' His commitment to the form was rooted in a sincere belief that great art could reflect and capture the beauty of nature for eternity. As he put it, 'What is fair in men passes away, but not so in art.' Elsewhere in his notebooks, he wrote, 'Painting embraces and contains within itself all the things which nature produces or which results from the fortuitous actions of men.'

Painting was, he contended, intrinsically related to the divine. It is not just 'the only imitator of all visible works of nature' but 'born of nature – or, to speak more correctly, we will say it is the grandchild of nature; for all visible things are produced by nature, and these her children have given birth to painting. Hence we may justly call it the grandchild of nature and related to God.'

It should come as no surprise that da Vinci – polymath and master of a disparate array of disciplines – considered painting the supreme art form, above even his other great artistic love, music. He once said of his painting, 'I give the degrees of things seen by the eye as the musician does of the sounds heard by the ear.' His passion for painting was anchored in considered and reasoned – if contentious – argument. Take, for instance, his following spirited explication of why the painter's art bests that of the musician and the poet:

The eye, which is called the window of the soul, is the principal means by which the central sense can most completely and abundantly appreciate the infinite works of nature; and the ear is the second, which acquires dignity by hearing of the things the eye has seen. If you, historians, or poets, or mathematicians had not seen things with your eyes you could not report of them in writing. And if you, O poet, tell a story with your pen, the painter with his brush can tell it more easily, with simpler completeness and less tedious to be understood. And if you call painting dumb poetry, the painter may call poetry blind painting. Now which is the worse defect? To be blind or dumb? Though the poet is as free as the painter in the invention of his fictions they are not so satisfactory to men as paintings; for, though poetry is able to describe forms, actions and places in words, the painter deals with the actual similitude of the forms, in order to represent them. Now tell me which is the nearer to the actual man: the name of man or the image of the man. The name of man differs in different countries, but his form is never changed but by death.

Committed to breathing life into his paintings, da Vinci employed his scientific mindset, approaching challenges with both logic and steely determination. He analysed how we physically look at things in order that he could adapt his technique to most accurately replicate nature. He concluded that painting is concerned with ten attributes of sight: darkness and brightness; substance and colour;

form and place; remoteness and nearness; and movement and rest. He then set about writing a set of rules that artists have consulted ever since. Key to his importance in art history was his belief that painted figures should fully exist in the viewer's imagination. In his opinion: 'A picture or representation of human figures ought to be done in such a way as that the spectator may easily recognize, by means of their attitudes, the purpose in their minds.'

To this end, he urged his fellow artists to develop their skills so they might paint a variety of types of figures. Not for him works replete with faces that you cannot tell apart – a characteristic of many works produced in the centuries leading up to da Vinci's arrival on the scene. Instead he demanded 'a due variety in the figures, so that the men may not all look like brothers'. 'Whenever you make a figure of a man or of some graceful animal,' he once said, 'remember to avoid making it seem wooden; that is it should move with counterpoise and balance in such a way as not to seem a block of wood.'

Like many of life's greatest achievers, da Vinci was fiercely critical of his own work, a trait that constantly drove him to greater heights. And while he did not always take criticism well, he nonetheless realized that accepting critiques, analysing them and learning from them were all vital steps in improving one's own technique:

Surely when a man is painting a picture he ought not refuse to hear any man's opinion ... Since men are able to form a true judgement as to the works of nature, how much more does it behove us to admit

that they are able to judge our faults. Therefore you should be desirous of hearing patiently the opinions of others, and consider and reflect carefully whether or no he who censures you has reason for his censure; and correct your work if you find that he is right, but if not, then let it seem that you have not understood him, or, in case he is a man whom you esteem, show him by argument why it is that he is mistaken.

Ultimately, da Vinci was not interested in painting simply to produce pretty pictures. He believed the talented painter had a duty to hone his skills as far as he was able so as to be best able to depict the world around him and the emotionally complex individuals who inhabit it. In a sense, he regarded the artist as possessing an almost divine-like gift of creation:

If the painter wishes to see beauties that charm him it lies in his power to create them, and if he wishes to see monstrous things that are frightening, or buffoonish, or ridiculous or really pitiable, he can be lord and creator thereof.

Don't Just Look,
But See

'The mind of a painter must resemble a mirror
which always takes the colour of the subject
it reflects and is completely occupied by the
images of as many objects as are in front of it.'

LEONARDO DA VINCI, WRITING
IN HIS NOTEBOOKS

It is said that when he was painting *The Last Supper*, Leonardo da Vinci spent hours at a time standing in front of his work without laying a brush stroke upon it. Whether this is a true depiction is disputed but certainly several of his patrons were on occasion left to wonder quite what da Vinci did with his time. Perhaps embodying that medieval view that the artist was little more than a manual labourer, they struggled to understand that he could be working while not actually adding to what they could see. But da Vinci knew better than that. Just as important as putting brush to board or wall was to fully realize the work in his mind first. And a vital step towards that was to look at and absorb the environment around him so that he might find suitable models from the real world on which to base the imaginary one he was creating.

Da Vinci had an artist's eye like no other and he believed that the ability to truly 'see' (as opposed to merely look) was an integral skill that the artist had a responsibility to master. As he said, 'Therefore you must know, O Painter! that you cannot be a good one if you are not the universal master of representing by your art every kind of form produced by nature.'

He urged the aspiring artist to be patient in developing their skill of seeing. In one extract from his notebooks he likened the process to getting to the top of a tall building – a challenge to be achieved one step at a time. He went on to suggest to those 'whom nature prompts to pursue this art' that to attain a sound knowledge of the forms of objects, they must 'begin with the details of them'. On another occasion he gave the following detailed prescription for observing and recording:

> When you have well learnt perspective and have by heart the parts and forms of objects, you must go about, and constantly, as you go, observe, note and consider the circumstances and behaviour of men in talking, quarrelling or laughing or fighting together – the action of the men themselves and the actions of the bystanders, who separate them or who look on. And take note of them with slight strokes in a little book which you should always carry with you. It should be of tinted paper, that it may not be rubbed out, but preserved with great care, for the forms and positions of objects are so infinite that the memory is incapable of retaining them, wherefore keep these sketches as your guide and masters.

Da Vinci practised what he preached when it came to getting out and about among the public. By his own account, he observed people in the streets and piazzas of Florence as well as in the fields of the surrounding countryside, noting down their forms in a kind of

anatomical shorthand, inscribing an 'O' for the head, denoting an arm or leg with a straight or bent line, and so on. On returning home he worked these visual notes into completed form. His biographer, Cristoforo Giraldi, provided further confirmation of his methods:

> When Leonardo wished to depict some figure ... he went to the places where he knew people of that kind gathered, and he observed their faces and manners, and their clothing, and the way they moved their bodies. And when he found something which seemed to be what he was after, he recorded it in a metalpoint pen in a little book which he always had hanging at his belt.

DA VINCI'S NOSES

Leonardo da Vinci came to catalogue ten distinct types of nose in profile (straight, bulbous, hollow, prominent above or below the middle, aquiline, regular, flat, round or pointed), but eleven types in full face (equal thick in the middle, with the tip thick and the root narrow, or narrow at the tip and wide at the root; with the nostrils wide or narrow, high or low, and the openings wide or hidden by the point).

'When you have to draw a face by heart,' da Vinci advised, 'carry with you a little book in which you have noted such features; and when you have cast a glance at the face of the person you wish to draw you can look, in private, which nose or mouth is most like, or there, make a little mark to recognize it again at home.'

Reflecting his methodical approach to life, da Vinci attempted to establish hard and fast rules to ensure he looked at things in the most efficient way. His guidelines to this end included: 'Nature teaches us that an object can never be seen perfectly unless the space between it and the eye is equal, at least, to the length of the face.' There is a school of thought among da Vinci academics that argues that his eye and brain processed images in a far more effective way than the average person.

In his own words: 'We know for certain that sight is one of the most rapid actions we can perform. In an instant we see an infinite number of forms, still we only take in thoroughly one object at a time.' But in da Vinci's case the rapidity of the action may have been almost superhuman.

It is clear from his paintings that he had an extraordinary eye for detail. One need only consider the studies of drapery he made while an apprentice. But it also seems probable that he was able to view movement almost as if it was in slow motion. It was this ability, so the argument goes, that allowed him to perceive the mechanics behind the flapping of a bird's wings, which provided a basis for his thought experiments in human flight. Similarly, some of his depictions of water suggest he could see in microscopic detail how the laws of physics act on a

water droplet as it falls from the sky down to earth. As the great twentieth-century art historian, Kenneth Clark, noted: 'There is no doubt that the nerves of his eye and brain, like those of certain famous athletes, were really supernormal.'

Da Vinci was adamant that the artist must expend significant energy in order to observe and memorize the world around him. Furthermore, he should undertake the process without any distraction. He wrote:

His [the artist's] brain must be easily impressed by the variety of objects, which successfully come before him, and also free from other cares. The painter or draughtsman must remain solitary, and particularly when intent on those studies and reflections which will constantly rise up before his eyes, giving materials to be well stored in the memory. While you are alone you are entirely your own master and if you have one companion you are but half your own, and the less so in proportion to the indiscretion of his behaviour.

He freely acknowledged that following this rule of solitude might mean that the artist's acquaintances take it as a sign that the artist is 'crazy'.

His prescription for best practice within the studio was, however, in stark contrast. 'If you must have companionship, find it in your studio,' he wrote. Indeed, it was something he positively recommended:

I say and insist that drawing in company is much better than alone, for many reasons. The first is that you would be ashamed to be seen behindhand among the students, and such shame will lead you to careful study. Secondly, a wholesome emulation will stimulate you to be among those who are more praised than yourself, and this praise of others will spur you on.

He also laid out suggestions so that the artist may view and consider his own work most effectively even as he was producing it:

When you paint you should have a flat mirror and often look at your work as reflected in it when you will see it reversed, and it will appear to you like some other painter's work, so you will be better able to judge of its faults. You should often leave off work and take a little relaxation, because when you come back to it you are a better judge. It is good to retire to a distance because the work looks smaller and your eye takes in more of it at a glance and sees more easily the discords or disproportion in the limbs and the colours of the object.

Then there was that imperceptible 'inner eye' that da Vinci possessed to an extraordinary degree and which may best be thought of in terms of the imagination. His 'imaginative eye' was a muscle that he sought to train. He liked to play a game in which he would look at the nearest

wall and consider a stain upon it, or else find a stone with variegated patterns, and within these imperfections seek out 'a resemblance to various landscapes ... or to battles with figures darting about, or strange-looking faces and costumes: an endless variety of things which you can distil into finely rendered forms. And the same thing that happens with walls and stones can happen with the sound of bells, in whose peal you will find any name or word you care to imagine.'

Da Vinci, we might suspect, would have been a master of that child's favourite pastime of finding creatures amid the moving clouds. As he summed it up in his *A Treatise on Painting*: 'Merely throwing a sponge soaked in various colours at a wall will leave a stain in which a beautiful landscape can be seen.'

Keep Things in Perspective

'Perspective, therefore, must be preferred to all the discourses and systems of human learning.'

LEONARDO DA VINCI, WRITING
IN HIS NOTEBOOKS

One of Leonardo da Vinci's greatest painterly attributes was his mastery of perspective. Today, young children are taught the basic rules of perspective almost as soon as they pick up a crayon, but it represented a mighty progression at the time. When da Vinci began working, theories of perspective were still in their infancy. Up until then, individual images within a picture tended simply to float in undefined space. People and objects did not inhabit distinct geographical or spatial regions. Even the most skilled medieval artists struggled to give their works any three-dimensional sense. And without that, a painting will always struggle to seem naturalistic. This was a big problem for da Vinci, who believed 'the most praiseworthy form of painting is the one that most resembles what it imitates'.

His criticism of fellow painters was scathing:

The universal practice which painters adopt on the walls of chapels is greatly and reasonably to be condemned. Inasmuch as they represent one historical subject on one level with a landscape and buildings, and then go up a step and paint another

varying the point [of sight], and then a third and a fourth, in such a way as that on one wall there are four points of sight, which is supreme folly in such painters.

He did, however, have a workable solution to hand:

We know that the point of sight is opposite the eye of the spectator of the scene, and if you would have me tell you how to represent the life of a saint divided into several pictures on one and the same wall, I answer that you must set out the foreground with its point of sight on a level with the eye of the spectator of the scene, and upon the plane represent the more important part of the story large and then, diminishing by degrees the figures, and the buildings on various hills and open spaces, you can represent all the events of the history. And on the remainder of the wall up to the top put trees, large as compared with the figures, or angels if they are appropriate to the story, or birds or clouds or similar objects, otherwise do not trouble yourself with it for your whole work will be wrong.

Da Vinci thus came to be able to fill his works with a sense of depth, volume and distance. Furthermore, each painting was given a single main focal point – a truly significant innovation. The viewer started to feel as if they were looking out of a window on to the world, rather than seeing an array of spatially disconnected man-made

images. The key was to adopt a stringently scientific approach to establishing working rules. Luckily, da Vinci had the theories of a few recent forbears upon which to base his ideas, but he took them to a new level.

Filippo Brunelleschi (1377–1446), architect of the fabulous Duomo of the Cattedrale di Santa Maria del Fiore in Florence, had laid out some of the fundamentals of perspective, including the idea of a vanishing point – an imaginary point at which receding parallel lines viewed in perspective seem to meet. His ideas were adopted by some early Renaissance artists such as Masaccio and, most prominently, Leon Battista Alberti, who made the crucial conceptual breakthrough that 'vision makes a triangle, and from this it is clear that a very distant quantity seems no larger than a point'.

So it was that artists began to introduce a 'floor' into their pictures, upon which objects and figures were supported. This floor gave way to a horizon, upon which was a vanishing point. The artist could then begin painting images along imaginary parallel lines radiating out from this vanishing point to the forefront of the picture, with 'nearer' objects painted larger and farther apart than those that the artist wanted to appear in the distance. Suddenly, paintings had depth and space.

Luckily for da Vinci, his master, Andrea del Verrocchio, was a skilled exponent of perspective and schooled his pupil well. Soon da Vinci outstripped all his contemporaries. This was partly because he moved beyond the relatively simple theory of 'linear perspective' described above, and began to think in terms of 'aerial perspective' too.

Keep Things in Perspective

Aerial perspective relied on the fact that 'because of the atmosphere we are able to distinguish the variations in distance of different buildings, which appear placed on a single line'. He would go on to elucidate '3 branches of Perspective, which are: the diminution in the distinctness of the forms of the objects; the diminution in their magnitude; and the diminution in their colour'.

Being the great observer that he was, da Vinci figured out that distance didn't just make an object look smaller but it affected how sharp it appeared, and even its colour and tone. He wrote in his notes: 'Whenever a figure is placed at a considerable distance you lose first the distinctness of the smallest parts; while the larger parts are left to the last, losing all distinctness of detail and outline.' Again, the likes of Albertini had already made similar observations, but none analysed and codified the phenomena with such precision.

Over time, he began to establish a handy set of rules. So, for instance, a near object was painted in its 'true' colours while those further back were painted in progressively bluer tones. He also softened the lines of objects in the distance so that they almost seemed to meld into the background, such as the human eye renders a scene. He also laid down precise ground rules for studying a subject in nature, such as this assertion: 'When you draw from nature stand at a distance of nine times the height of the object wish to draw.' There were separate instructions for drawing human figures within a perspective framework. Among his clever sleights of hand was the following:

Dress your figures in the lightest colours you can, since, if you put them in dark colours, they will be in too slight relief and inconspicuous at a distance. And the reason is that the shadows of all objects are dark. And if you make a dress dark there is very little variety in the lights and shadows, while in light colours there are many grades.

Da Vinci being da Vinci, he even invented a machine – a perspectograph – consisting of a pane of glass fitted with a viewing slot to assist him in rendering perspective as accurately as possible. Perspective had at best been an afterthought until very shortly before da Vinci began working, and in preceding centuries it had hardly been a consideration at all. But da Vinci changed this forever, demanding that it be among the first skills for the aspiring artist to master. As he wrote:

The youth should first learn perspective, then the proportions of objects. Then he may copy from some good master, to accustom himself to fine forms. Then from nature, to confirm by practice the rules he has learnt. Then see for a time the works of various masters. Then get the habit of putting his art into practice and work.

His lessons on perspective have held good for centuries, allowing artists to instil their works with a degree of realism that simply hadn't existed before. He literally changed the art landscape. Only in relatively recent times

have mainstream art movements had the confidence to move away from his rules in search of new truths that exist independently of realism. But we may be sure that the likes of Picasso, Dalí, Kandinsky and Jackson Pollock knew the rules of perspective before they chose to disregard them. Da Vinci, by contrast, had to write and master them almost from scratch.

His results were, needless to say, breathtaking. Vasari expressed his awed admiration in response to a cartoon (which in this context refers to a preparatory drawing for a painting, fresco or tapestry) that da Vinci produced for the king of Portugal. It was a tapestry telling the story of Adam and Even in the Garden of Eden: 'There is a fig tree, for example, with its leaves foreshortened and its branches drawn from various aspects, depicted with such loving care that the brain reels at the thought that a man could have such patience.'

Indulge Your Playful Side

'He was the inventor and arbiter of all refinement and delights, especially theatrical ones.'

PAOLO GIOVIO IN *VITAE VIRORUM*,
MID-SIXTEENTH CENTURY

Da Vinci approached his work with an energy and seriousness of intent that few individuals have ever come close to equalling. Nonetheless, it is unfair to suggest that he did not have a lighter side. In fact, he had a mischievous sense of humour and a love for the grandly flamboyant gesture. There is an old maxim that says all work and no play makes Jack a dull boy. In da Vinci's case, he was almost constantly at work but found plenty of opportunity to inject a streak of playfulness into his labours.

The clearest expression of his playfulness came in his designs for the grand spectacles that were regular features of public life in the Italian city states. Successive wealthy patrons called on his talents as a costume and stage designer and curator of public events. From his youth he was witness to the flamboyant pageants that the Medici funded in order to enhance the prestige of Florence and their own family name, as well as to cement public support. Here he would have seen the spectacular stage props that inspired, for instance, the 'flying birds' he designed as theatre props in later years.

However, it was not until he moved to Milan in 1482 that he cemented his reputation as a real master of the theatrical. While Florence may have been the hub of the

Renaissance, it was to some extent more 'respectable' and 'proper' than Milan. Milan was a more populous city whose duke, Ludovico Sforza, encouraged a rather more decadent and flamboyant atmosphere – a fact that may have drawn da Vinci there in the first place.

If a single event epitomized his talents in this area, it was the marriage of Duke Gian Galeazzo (the nephew of Ludovico Sforza) to Isabella of Aragon. Da Vinci was commissioned to produce costumes and a set for an operetta to be performed as part of the wedding feast. The show, *Il Paradiso*, was written by Bernardo Bellincioni but by common consent da Vinci was the star turn of the night.

The walls of the stage were draped in silks and green foliage until, at the crucial moment, the silks were drawn back to reveal a vision of paradise. Through cunning use of gold, lights and glass, da Vinci created a sparkling night sky, complete with the planets set into niches and the twelve signs of the zodiac. It was, all agreed, a remarkable spectacle and showed da Vinci not only as an aesthete but a special-effects whizz.

A few months later he was putting on a pageant on behalf of one Galeazzo da San Severino to celebrate Ludovico's own wedding to Beatrice d'Este. For this celebration he kitted out a platoon of folkloric (and, by all accounts, terrifying) 'wild men' on horseback, with San Severino himself decked out like a dragon. While da Vinci was masterful at capturing natural beauty, he was also fascinated by fantastical monsters and grotesques, a passion given full reign on this particular night. On another occasion, after the Sforzas had been supplanted by the French in Milan,

da Vinci delighted the visiting king of France by creating a mechanical lion. The creature walked towards the monarch before its chest opened up to reveal a fleur-de-lis, to the delight and astonishment of all present. Da Vinci knew his stagecraft and could play the ringmaster par excellence.

His playful side also comes through at regular intervals in his notes. He records several jokes and bawdy tales, which might not leave a modern reader rolling in the aisles but suggest he was something of a comedian and raconteur. In 1487 he authored a spoof traveller's epistle, which he sent to a fellow Florentine in Milan, Benedetto Dei. The missive describes travels in an imaginary land and is highly politically incorrect, including crude racial stereotypes. It was, perhaps, an affectionate joke at Dei's expense: Dei was known for his travel writings and da Vinci may have been hinting that they were somewhat embellished. Despite the discomfort we might feel at some of the characterization da Vinci adopted, it is still a sophisticated literary endeavour, doubtless written with a glint in his eye.

His writings also include countless riddles and word games, often turning on a pun. Again, they have not all weathered well over the centuries but they do show his lighter side. In one of his riddles we have the description of a man who walks atop the trees, which turns out to be a reference to a man wearing wooden clogs. Another reads: 'There will appear gigantic figures in human shape, but the nearer you get to them, the more their immense stature will diminish.' This, we discover, are the shadows cast by men at night with lamps.

He also created rebuses, in which images are substituted

for words and sounds. He made up at least 150 across the years, such as one depicting an 'o' and a pear (*pera* in Italian) to stand for *opera* (the Italian word for 'works'). He showed his own name as a lion on fire (*leone* + *ardere* = *Leonardo*). He must have spent many hours turning over such word games in his mind. Then there are the thirty or so fables. Many had a satirical bent, especially at the expense of the Church, while others were really rather risqué, including one in which an artist was asked how he could be responsible for producing such beautiful works of art but ugly children. His reply was that he produced his paintings in the daylight but his babies at night. How the reader must have blushed!

Finally, there is evidence that da Vinci was a practical joker prepared to go the extra mile for dramatic effect. Vasari describes how the otherwise animal–loving artist used quicksilver to attach tiny model wings, horns and a beard to a captive lizard. He would then unleash the unearthly beast on unsuspecting friends and acquaintances, invoking first terror and then hilarity. Another of his favourite japes was to clean the intestines of a dead bullock and compress them until they fitted into the palm of his hand. He would then appear at parties, where he would use bellows to inflate the bovine innards until they filled the greater part of the room and left his guests pushed into a corner.

Given the sober nature of much of the work he left us and the tales of his unstinting commitment to being the best at everything he did, it would be easy to think of da Vinci as a rather joyless character. He was, though, a man well known for his sociability and bonhomie, who had a mischievous playfulness to compare with the best of them.

MAKE BEAUTIFUL MUSIC

> '[Music is the] the representation of
> invisible things.'
>
> LEONARDO DA VINCI ON THE ART
> OF MUSICIANSHIP

As previously mentioned, when da Vinci relocated to Milan in 1482 he took the somewhat surprising step (at least in modern eyes) of presenting himself as a musician fit to grace the court of the famously music-loving Ludovico Sforza. Was this a genuine attempt by da Vinci to reinvent himself? Probably not, although after all the difficulties he had faced as a painter in Florence, it no doubt appealed to his sense of fun to present himself as master of something entirely different from that in which he had made his name.

Da Vinci was an exceedingly adept lyre player. The type of lyre he played was not the harp-like sort that we associate with chubby-faced cherubs, but was more like a violin. Vasari relates that da Vinci designed his own extraordinary version of the instrument that, if the account is true, must have delighted the eyes as much as the ears. Crafted from silver, it took the form of a horse's skull and had a tone that was satisfyingly deep and resonant. The anecdote is suggestive of da Vinci's view that music and spectacle should be married together, just as they were during the fabled performance of *Il Paradiso*.

We do not have a record of the styles of music that da Vinci played but the likelihood is that he performed a roster

of light-hearted carnival songs and frothy song-poems known as *frottole*. There may have been some love ditties too, and no doubt a few dirty verses, as written by the likes of his friend, Antonio Cammelli. As well as being brilliant on the lyre, da Vinci had a strong voice and was described by Vasari as 'the most skilled improviser in verse of his time'.

He was a composer too, although there are no extant examples of his work. In fact, that is not quite technically true. Sometimes da Vinci employed musical notation in his riddles, using the notes (Do, Re, Mi, Fa, Sol, La, Ti) to represent whole words or syllables, though clearly the melodies were created to serve a literary purpose rather than for their musicality.

His love of music also flowed into his work as a set designer for masques and pageants. Consider, for instance, the extraordinary drawing we have of a costume in which a reveller sports an elephant's head from which protrudes a trumpet, while the trunk doubles as a flute-like instrument. Quite how the party-goer produced music is not obvious, although the costume incorporates a large belly that may have housed bellows so that the whole extraordinary contraption could be played like a set of fantastical bagpipes.

As with almost everything to which he turned his hand, da Vinci inevitably excelled as a musician. It is perhaps one of life's minor tragedies that he lived in a pre-recording age. Nonetheless, music filled his heart with joy, a joy that he was more than willing to share.

Study, Study, Study

'The desire to know is natural to good men.'

LEONARDO DA VINCI, WRITING
IN HIS NOTEBOOKS

Had Leonardo da Vinci been born as the legitimate son of Ser Piero, it is likely that he would have been groomed to follow in the family profession of notaries. This would have meant being provided with the best schooling available, with an eye to going on to university. As it was, Leonardo received little in the way of formal education. This is, on reflection, a quite astonishing fact. The person whom many consider to have possessed the brightest, broadest mind in history received only the most basic schooling. Being nothing if not a self-starter, thankfully he took it upon himself to fill the gaps. Such was his hunger for learning that it has even been suggested that his desire to study got in the way of him completing several major works.

Da Vinci's early education was largely restricted to reading, writing and arithmetic. According to Vasari, within these constraints he showed himself to be a sparky if frustrating student. His talent with numbers particularly shone through so that in a few months he had made such progress that he bombarded his teacher with countless questions and very often outwitted him. Nor was he a slouch when it came to literacy, as evidenced by the

thousands of pages of notes he made in later life. However, if we consider the brilliance da Vinci exhibited in most things to which he turned his hand (including maths), his writings rarely reach the heights in terms of artistry. His notebooks are astounding for their breadth and depth, and for the great knowledge and wisdom they contain, but they are not startling works of literary merit.

Vasari provides us with further information about Leonardo's early education. It seems likely that he had music lessons, and of course he was forever drawing and sculpting, 'which suited his imagination better than anything'. However, the biographer claims Leonardo would have got even more from his lessons had he not been 'so volatile and unstable'. 'He set himself to learn many things,' Vasari wrote, 'only to abandon them almost immediately.' This propensity to become distracted – da Vinci was almost magpie-like in his desire to pick up the next shiny piece of new knowledge – was a trait that dogged him all his life.

Da Vinci recognized, however, that education – both formal and informal – was vital if he was to capitalize on the chances life threw at him. When he was a little older he set about educating himself in areas his tutors had not touched. Since Leonardo was prohibited from going to university, he was not, for instance, taught Latin. At the time, this was a serious bar on accessing many of the most important texts across academic disciplines. Leonardo was thus condemned to a future as a second-rate scholar, and it was a situation that left him with a rightful chip on his shoulder. His annoyance is evident, for example, in

the following assertion: 'Because I am not well educated I know certain arrogant people think they can justifiably disparage me as unlettered.'

Da Vinci was not content to let his frustration fester. Instead he set out to teach himself the ancient language. In the 1480s he filled innumerable pages with lists of Latin vocabulary and studied classic primers such as Aelius Donatus's *De octo partibus orationis*. This was just a beginning, though. In pursuit of self-improvement, Da Vinci devoted long hours to study. He covered everything from mathematics (as opposed to simple arithmetic) to botany, philosophy (he was well versed in the teachings of the Greek greats, including Aristotle and Plato, as well as the works of the leading Renaissance humanists), optics, mechanics, anatomy, geography, astronomy, geology, hydrology, aeronautics … the list goes on almost without end. And as his fame spread, so he was more easily able to gain access to the leading names in each of these fields. Da Vinci was a brilliant autodidact but also sought out the teachings of acknowledged experts.

His love for learning was partly the result of his inbuilt desire to make sense of the world, but was also a reflection of his ambition. Not necessarily ambition for wealth and fame (although he sneered at neither), but ambition to produce work of the highest standard. His desire to be the very best is illustrated by another anecdote from Vasari. Although it may be apocryphal, it is also decidedly credible. It involves Verrocchio's painting of *The Baptism of Christ*, which dates to *c.* 1472. This was a collegiate work (that is, created by several people in Verrocchio's workshop) and

one of the first to include a major contribution by the youthful da Vinci. He painted an angel to the left of the picture as we view it. While Verrocchio was no slouch as a painter himself, the eye is undeniably drawn to his apprentice's vibrant cherub – something of which Vasari says the master was only too aware, to the extent that Verrocchio never again picked up a paintbrush, deflated in the knowledge that he could never attain the heights of his apprentice. Whether Vasari embellished this story or not, it certainly ties in with da Vinci's comment that, 'He is a poor disciple who does not exceed his master.' Second best was simply not good enough. Nor could he abide self-satisfaction, an attitude reflected in his scathing dismissal of the artist skilled only in one area: 'Nor is the painter praiseworthy who does but one thing well, for there can be no mind so inept, that after devoting itself to one single thing, and doing it constantly, it should fail to do it well.'

His ability to devote such enormous energy to studying and self-improvement is related to his mighty work ethic. As he once noted: 'Thou, O God, dost sell us all good things at the price of labour.' Leonardo failed to complete a great many projects not through lack of effort but because he was always intent to take up the next challenge. Hence he wrote this exhortation against laziness: 'those minds which instead of exercise give themselves up to sloth … are like the razor here spoken of, and lose the keenness of their edge, while the rust of ignorance spoils their form'.

His enormous energy is apparent in the many sets of rules he evolved towards a comprehensive guide to artistic

'best practice'. Take his advice, for instance, on making the head of a statue: 'Divide the head into 12 degrees and each degree divide into 12 points, and each point into 12 minutes, and the minutes into minims and minims into semi-minims. Degree − point − minute − minim.' Nothing is left to chance. Accurate and diligent process was vital to achieving the end results that da Vinci desired.

BE HIGHLY ORGANIZED

The high value da Vinci gave to good order in everything is revealed in a note he wrote around 1490: 'If you want to see how a person's soul inhabits his body, look at how his body treats its daily abode. If the latter is disordered, so the body will be kept in a disordered and confused way by the soul.'

Da Vinci expected the aspiring painter to push himself to the limit in order to achieve the best results. But in order to shortcut criticism, the artist should strive to master his discipline:

> We know very well that errors are better recognized in the works of others than in our own; and that often, while reproving little faults in others, you may ignore great ones in yourself. To avoid such ignorance, in the first place make yourself a master

of perspective, then acquire perfect knowledge of the proportions of men and other animals, and also study good architecture. These forms are infinite, and the better you know them the more admirable your work will be.

Da Vinci also recommended travel, extolling the artist to 'quit your home in town, and leave your family and friends, and go over the mountains and valleys into the country'. This is something of an irony, given that da Vinci was himself not the best travelled of men. At a time when European explorers were discovering a hitherto unknown world, all the available historical evidence suggests that he rarely if ever made it beyond the borders of Italy (there may have been a brief foray to Hungary in the 1480s) until his relocation to France in his dotage. Nonetheless, he was true to his own word in that he was prepared to uproot as necessary in the interests of his work. This meant first turning his back on his beloved Tuscan countryside for the bustle of Florence, then moving to Milan and back to Florence again, with occasional sojourns in other city states. He satisfied his lust for communing with nature by regular excursions into the countryside (he was what we might now recognize as something of a rambler). So while he was no Columbus or Magellan, he was a man who attempted to expose himself to new experiences and influences even once he had achieved a level of success that might have allowed him to put his feet up at home.

In the end, da Vinci believed that you set yourself on the path to success by putting yourself in the way

of experience, improving your knowledge and skills, and being prepared to work hard. He had an almost pathological fear that to cease to learn was to get on the fast track to stagnation and decrepitude:

> Learning acquired in youth arrests the evil of old age; and if you understand that old age has wisdom for its food, you will so conduct yourself in youth that your old age will not lack for nourishment. For nothing can be loved or hated unless it is first known.

Or, in even simpler terms: 'Just as iron rusts unless it is used and water putrefies or, in cold turns to ice, so our intellect spoils unless it is kept in use.'

Read Like
da Vinci

'The most relentlessly curious man in history ...'

Leonardo da Vinci's lust for self-improvement was reflected in the wide-ranging library that he accumulated over his lifetime. We are able to garner certain facts as to what it comprised from da Vinci's own notes. We know, for instance, that by the 1490s he was in possession of some forty volumes (a significant number by the standards of the time) and that as of 1504 he owned 116 tomes (which he colourfully reported included twenty-five small books, two large books, sixteen very large books, six books on vellum and one book bound in green chamois). They covered subjects as diverse as science and mathematics, religion and philosophy, language, agriculture, law, architecture and even chiromancy. Then there are the literary texts, encompassing both standard texts from the classical world and cutting-edge works from contemporary Florentine authors. The following does not represent a complete list but gives a taste of the breadth and range of da Vinci's reading:

- The Bible and a volume of Psalms, texts that we might expect to have been in the possession of any literate man operating in Renaissance Italy.

Read Like da Vinci

- Aesop's *Fables*. Aesop (*c.* 620–564 BCE) was an ancient Greek storyteller credited with creating a series of famous fables, often featuring animals with human characteristics and providing the reader with moral lessons. Da Vinci's own fables were no doubt influenced by Aesop's, even though he did not plunder their content. Intriguingly, da Vinci owned a copy of the *Fables* in French, which suggests he may have learned the language following the French invasion of Milan that occurred while he was resident there.

- Livy (*c.* 64/59 BCE–17 CE). The historian wrote an account of Rome's civilization from its mythological foundation through to his own lifetime. It was a key text in an age intent on re-exploring the glories of the ancient world.

- Ovid (*c.* 43 BCE–18 CE). Ovid was one of the great composers of verse in the ancient Roman world. He is particularly famed for his timeless love poetry and also for the fifteen-book *Metamorphoses* cycle, telling some 150 myths. His verse had a profound influence on Dante, among others.

- *Naturalis Historia* by Pliny the Elder (23–79 CE), a scientist and natural philosopher (as well as a military commander and writer). His most important work, *Naturalis Historia* (*Natural History*) served as a model for all future encyclopaedias. It aimed to encompass all the knowledge of the ancient world and extended far beyond what the modern reader would consider 'natural history'. Pliny famously died during the eruption of Mount Vesuvius that destroyed Pompeii and Herculaneum.

- The *Chronica Majora* by Isidore of Seville (*c.* 560–636). The one-time Archbishop of Seville who was later canonized and described as the 'last scholar of the ancient world', intended his *Chronicle* to be a complete history of mankind.

- *Liber Lapidum* (*The Book of Stones*) by Marbodeus (*c.* 1035–1123). Marbodeus was a French clergyman and produced this landmark work on mineralogy.

- The *Works* of Albertus Magnus (*c.* 1200–80). Albertus was a Catholic bishop who was later made a saint. He is one of only thirty-six individuals to be named a Doctor of the Catholic Church. Da Vinci had several of his volumes, in which he laid out his interpretation of Aristotelean philosophy and science.

- *The Divine Comedy* by Dante Alighieri (*c.* 1265–1321). Dante was an Italian whose works (from which da Vinci quoted freely in his notebooks) remain among the great texts of European literature.

- Petrarch (1304–74), an Italian humanist poet of the early Renaissance. His lyrical verse, collected in works such as *Canzoniere* (*The Songbook*), had an enduring influence on European culture as a whole and the development of the modern Italian language in particular.

- *Il Quadriregio* by Federico Frezzi (*c.* 1346–1416). Frezzi was an Italian bishop, academic and writer. *Il Quadriregio*, an epic, didactic poem, was his masterpiece and owed much to Dante.

- *The Travels of Giovan di Mandevilla* (*John Mandeville*). A work that appeared in the late 14th century, its origins are unclear but John Mandeville seems to have been

a fictionalized persona. It is still debated which of the international travels described were really undertaken by the author and which were merely imaginary. Nonetheless, in da Vinci's own time such eminent figures as Christopher Columbus made reference to its content.

- *Facetiae* by Poggio Bracciolini (1380–1459). Bracciolini was a scholar who rediscovered several notable Latin manuscripts in the great libraries of Europe. His *Facetiae*, however, was a collection of bawdy, comedic tales rendered in Latin.

- The *Works* of Francesco Filelfo (1398–1481), another Italian Renaissance humanist who schooled himself in the traditions and texts of both the Latin and Greek worlds. Da Vinci owned his *Epistles* and *On the Immortality of the Soul*. There is evidence that the two men were distant cousins.

- *Morgante* by Luigi Pulci (1432–84). Pulci was a Florentine poet and a favourite of the Medici, for whom he also carried out diplomatic work. *Morgante*, part-epic and part-parody, tells the tale of a giant who converts to Christianity and joins a knight on various adventures. Drawing on ancient traditions and contemporary Florentine life and language, Pulci had something of a racy reputation. Da Vinci also owned *Driadeo d'amore*, a work by Luigi's brother, Luca.

- *Theologia platonica* (*Platonic Theology*) by Marsilio Ficino (1433–99). Ficino was a Catholic priest and humanist philosopher, and a leading figure of Neoplatonism. *Theologia platonica* is a multi-volume work that

investigates the nature of God and the human soul, drawing heavily on the philosophy of Plato (including the idea of the immortal soul).

- *Trattato di architettura* (*Treatise on Architecture*) by Francesco di Giorgio Martini (1439–1501). Di Giorgio was a Sienese artist and architect. His *Trattato* was highly influential in da Vinci's time, detailing innovative design features as well as exploring broader issues of city planning.
- *Das Narrenschiff* (*The Ship of Fools*) by Sebastian Brandt (1457–1521). A satire on the state of the Church by the German humanist theologian. The work was also notable for being published with engravings by the great German artist, Albrecht Dürer.
- *De re militari* (*On Warfare*) by Roberto Valturio (1505–75). Valturio was a writer and engineer from Rimini whose military treatise was widely circulated in da Vinci's time.
- *Sonnets* by Gaspare Visconti (1538–95). A collection of verse by the contemporary Archbishop of Milan.

Unite Art and Science

'Science is the captain, and practice the soldiers. Those who fall in love with practice without science are like a sailor who enters a ship without a helm, or a compass, and who can never be certain where he is going.'

LEONARDO DA VINCI, WRITING
IN HIS NOTEBOOKS

For most people, Leonardo da Vinci enters their conscience as an artist, and specifically as the artist who painted the *Mona Lisa*. However, it is his commitment to science as well as art that sets him apart from all the other great artist figures of his age. We might wonder how one man could be so skilled across both the arts and sciences. The answer is that he recognized no intellectual separation between his work as an artist and a scientist. Instead the artist and the scientist were conjoined, their ideas flowing effortlessly together and informing his practice in whatever discipline he happened to be focusing upon on any given day.

We have already seen how, for instance, mathematical calculation underlay da Vinci's unprecedentedly sophisticated grasp of perspective. In pages to come we will see how the *Mona Lisa* could not have been painted had he not devoted countless hours to the study of anatomy. His anatomical drawings, meanwhile, progressed that field of science thanks in no small part to his extraordinary gifts as a draughtsman, first learned in Verrocchio's studio. We will also see how his drawing skills and artist's eye allowed him to speculate as to how man might, among other things, fly, create a machine gun and re-route a river.

Unite Art and Science

The Renaissance is popularly seen as primarily a cultural flowering but it is remiss to ignore its scientific aspects – aspects that da Vinci's work typifies. By referring back to classical texts, the Renaissance world refused simply to accept 'truths' over which the Church had wielded control for centuries. There was now a curiosity to explore everything – the natural world, the nature of man himself and our position within the universe – and to seek empirical evidence (based on observation and experience) of long-held assumptions.

Da Vinci was a product of his age and harboured certain widely held beliefs and suspicions. He was, for instance, wary of doctors and modern medicine in general. Yet even this was a fairly logical position to take, given that the fifteenth-century medical profession was not the rigorously disciplined one we know today but was replete with quacks and charlatans peddling all manner of unsuitable cures for a profit. Da Vinci instead preferred advice derived from medical folklore that had a base in common sense.

He was also open-minded to the idea of alchemy, that branch of science most famously directed towards producing gold from base metals and long since dis-credited. Yet da Vinci developed a genuine interest in it, not least inspired by the expertise of his long-term companion, Zoroastro. Indeed, da Vinci spent many hours in his later years conducting metallurgical experiments. While the naive alchemist may seem a laughable figure to the modern mind, da Vinci's faith in its potential was rooted in a not unreasonable premise: that materials may

transmute into other natural materials. If the human body might die and disintegrate into a form that gives sustenance to new life, might base metal be transformed into something more precious?

He was, on the other hand, utterly dismissive of what he called 'the sister of Alchemy': necromancy, adherents of which claim to be able to predict the future by communicating with the dead. Da Vinci described it instead as a 'lie' believed by 'the silly multitude', dismissing out of hand the idea that a spirit can 'exist in the elements without a body'. This was to his mind nothing more than medieval hokum with no place in the Renaissance world. Where alchemy confined itself to 'the simple products of nature' and could thus be subjected to verifiable tests, necromancy relied on a belief in the unseen and a faith in the unprovable – utter anathema to his empiricist mentality.

As a model of the modern scientist, he would not take anything for granted or rely on second-hand accounts. Nothing was true until it had been proven as such – a revolutionary idea in a world where most people lived their lives according to articles of faith. It was an approach he adopted in his work as an artist, too. He noted, for instance, that it might be easier for the artist to garner his experience from the works of other artists or from the pen of a poet. 'Wouldn't that be more convenient,' he pondered, 'and less tiring, since you can stay in a cool place without moving about and exposing yourself to illness?' Except, of course, the experience would be incomplete, even false. By relying on third-party experiences, the young artist can never truly 'receive the reflections of

bright places' or 'see the shady valleys'. As he succinctly put it: 'Wisdom is the daughter of experience.'

Empiricism thus lies at the heart of da Vinci's life work, spanning and uniting his practice as both artist and scientist. Knowledge does not come because one believes what one is told, but because it has been seen, heard, smelled, tasted, and felt first-hand. Writing in the Codex Trivulzianus, da Vinci stated: 'All our knowledge has its foundations in our senses.' That is not to say that knowledge passed on by another is without merit. 'The knowledge of past times and of the places on the earth,' he said, 'is both an ornament and nutriment to the human mind.' But that knowledge had to be verifiable. Such was his devotion to the principle that he sometimes signed himself as *Leonardo Vinci disscepolo della sperientia*, which roughly translates as 'disciple of experience'.

There were, inevitably, some missteps along the way. Take, for instance, the following incorrect assertion: 'Men born in hot countries love the night because it refreshes them and have a horror of light because it burns them; and therefore they are of the colour of night, that is black. And in cold countries it is just the contrary.' This may look to us, five hundred years on, like a rather crass generalization and offensive in its attempts at racial stereotyping. However, da Vinci was not looking to make a political point or to pass any judgement. Instead he was looking at a fact (that the indigenous populations of certain countries have darker skin than those in other countries) and attempting to ascribe its causation. There is a logicality to his argument even though it is wrong, and

a desire to answer a question by studying the evidence. It is not a case study in perfect empiricism, since we can see how da Vinci has attempted to mould the evidence to fit the case, rather than the other way round. Nonetheless, it is indicative of a sincere desire to reveal truth rather than peddle myth.

This search for truth is another unifying feature of his artistic and scientific endeavours. 'To lie is so vile,' he noted, 'that even if it were in speaking well of godly things it would take off something from God's grace; and Truth is so excellent, that if it praises but small things they become noble.' This dichotomy was one he explored elsewhere in his notebooks, as when he wrote: 'Beyond a doubt truth bears the same relation to falsehood as light to darkness ...'

AVOID SELF-DECEIT

Da Vinci understood that deceit can be perpetrated by an individual upon himself as easily as upon someone else, commenting, 'The greatest deception men suffer is from their own opinions.' In other words, you should not carry preconceived ideas but should be like a blank canvas, primed to be filled with the colours of your experience.

Allied to his pursuit of truth was a desire for simplicity. While we may gaze at his artworks in awe and study his scientific designs with wonderment, we should not lose sight that among his greatest gifts was an instinct for keeping things simple. It came as the result of years of diligent study and practice but his paintings are so powerful because they express simple, universal truths. His method was complex and brilliant in the interests of producing work that seems natural, unlaboured and, in the best sense, straightforward.

The pursuit of elegant simplicity equally informed his scientific projects. In an extract from the Codex Atlanticus we get a flavour of his approach and the philosophy behind it:

> When you want to achieve a certain purpose in a mechanism, do not involve yourself in the confusion of many different parts, but search for the most concise method: do not behave like those who, not knowing how to express something in the appropriate vocabulary, approach it by a roundabout route of confused long-windedness.

In the same Codex, there is a partial list of the social circle da Vinci inhabited. Of the five identifiable names noted, four of them were scientists. They included: Paolo dal Pozzo Toscanelli, a famed behemoth of Florentine science who wrote a treatise on perspective and was noted as an astronomer, astrologer, mathematician, geographer, physician and linguist; and Joannes Argyropoulos, a

leading Aristotelian scholar who emphasized the analytical and scientific elements of the great Greek philosopher's teachings. Both men were devoted advocates of empiricism, using observable data to question long-held beliefs. Toscanelli, for instance, was among the first seriously to question the Ptolemaic world map, which dated to the second century CE. (Toscanelli's own map of the globe, complete with miscalculations as to the size of the Earth, travelled with Christopher Columbus on his voyages to the New World and contributed to Columbus's belief that he had found Asia, rather than an entirely new continent.)

It is telling that da Vinci should have made particular note of these scientist-friends when comments about his artistic circle are scant across his copious notes. Where fellow artists often infuriated or disappointed him, one has the sense that he saved his greatest admiration for men of science. These were, we can assume, people he considered at least on an intellectual par with him, though perhaps not a direct challenge to his position in society. Whereas Michelangelo might threaten da Vinci's status and livelihood, the likes of Toscanelli and Argyropoulos posed no such threat even as they pushed him on to new heights of understanding and endeavour.

Science, for da Vinci, was 'the observation of things possible, whether present or past'. It was the key to everything – knowledge and wisdom, life and death, the hope that one day man might fly, and the means by which he could paint the *Mona Lisa* and *The Last Supper*. Some have even argued for da Vinci as the first great modern

scientist. Certainly, his fascination with the world in all its intricacy prompted him to seek out an unparalleled array of knowledge. As Edward MacCurdy, the noted da Vinci scholar, argued:

Before Copernicus or Galileo, before Bacon, Newton or Harvey, he uttered fundamental truths the discovery of which is associated with their names. 'The sun does not move.' 'Without experience there can be no certainty.' 'A weight seeks to fall in the centre of the Earth by the most direct way.' 'The blood which returns when the heart opens again is not the same as that which closes the valve.'

It is easy to argue that the divide between art and science, and by extension the artist and scientist as personalities, is one constructed by society. The hard proof comes in the form of Leonardo da Vinci.

Innovate and Experiment ...

'If they disparage me as an inventor, how much more they, who never invented anything but are trumpets and reciters of the works of others, are open to criticism.'

LEONARDO DA VINCI, WRITING
IN HIS NOTEBOOKS

One of da Vinci's greatest attributes – and occasional foibles – was his willingness (indeed, eagerness) to try something new. Whether in his artistic or scientific toils, he was continually looking for new ways of doing things. As the quotation above suggests, he had little interest in repeating the achievements of others. He wanted to break new ground in everything to which he set his mind.

Take, for starters, his work as a painter. To us viewing his works today, da Vinci seems like the very model of a classical painter, reproducing figures and natural environments in a naturalistic style. Yet, as we have already seen, this was a revolutionary leap forward in the history of art. And while he was not the first to aim for truly realistic depictions of the world around us, he developed and evolved the methods that produced results light years beyond what preceded him. We can see how quickly he developed his skills from making his painterly debut around 1470 on Verrocchio's *Tobias and the Angel* to his stunning work within a few years, when he was still in his twenties, on *The Madonna of the Carnation*, another work that came out of Verrocchio's studio.

However, not all his innovations brought great results. In terms of failures, his worst was surely his attempt to slow down the process of fresco painting (essentially by dabbling with the composition of the paints he used) in order to give him time to assess and retouch his work – a misadventure that contributed directly to the degradation of key works. Nonetheless, other technical experiments reaped far greater rewards. While oil paints had established themselves among the artistic fraternity of northern Europe, da Vinci was one of the first to employ them seriously in Italy. Among the advantages of oils that he exploited was the ability to work more slowly, building up layers of paint to accentuate shading and texture.

Oils also allowed him to develop the *sfumato* effect. *Sfumato* (to evaporate like smoke) was arguably da Vinci's single greatest technical innovation. It allowed for the gradual, imperceptible transition between colours and tones. Without relying on lines or borders to signpost transitions, it made possible a new level of sophistication in, for instance, rendering facial features and depicting a landscape in the distance. The *Mona Lisa* represents the most famous expression of the technique by anybody in any age, to say nothing of the incomparable incorporation of perspective into the work.

He introduced several other weapons into the artist's armoury. For example, da Vinci is the first known exponent of conscious anamorphosis, a process in which objects are painted in a fashion so that they appear distorted out of all recognition until viewed at a particular angle. It is a highly

technical skill, demanding complete mastery of perspective, and adds both intrigue and amusement to an artwork. Hans Holbein (1497–1543), the German artist who found particular favour with Henry VIII, is arguably the most famous practitioner of anamorphosis, as in *The Ambassadors*. In this work, a curious shape stretches diagonally across the bottom of the image, which when viewed from a suitably acute angle is revealed as a skull. But in 1485, almost fifty years before *The Ambassadors* was first shown, da Vinci created an anamorphic image of an eye.

Yet it was as a scientist that he was arguably even more cutting-edge – a fact his brilliance as an artist went some way to obscuring. Furthermore, his habit of writing backwards (see Mirror Writing on page 187) meant that much of his scientific work was not properly recognized until many years after his death. Da Vinci was not afraid to fail but he was terrified of not trying in the first place. As an artist, he aimed to channel the beauty of the natural world into his work. As a scientist, he looked to interpret its wondrous workings and adapt them to new effects. Far better to strive and fall short than to be the one who stands on the sidelines, condemning those making the attempt.

It is folly to attempt to list da Vinci's scientific break-throughs in their entirety, so many are they. However, a short list of his discoveries and advances gives a hint of the magnitude of his achievement. Vasari began the process of revelation, informing his readers that among his many achievements da Vinci was 'the first to propose reducing the Arno to a navigable canal between Pisa and Florence.

He made designs for mills, fulling machines, and engines that could be driven by water-power' and produced 'plans showing how to excavate and tunnel through mountains without difficulty ... how to lift and draw great weights by means of levers, hoists and winches, and ... pumps to suck up water from great depths'.

Other inventions included a new type of oven and a device for measuring moisture in the air. He also left us drawings for a hand-held telescope and an early version of contact lenses, plans for parachutes and flying machines, submarines and diving suits, suggestions for how to harness solar power by use of a 'mirror of fire' (consisting of a concave mirror), city maps of unrivalled detail, and drawings of the human body centuries ahead of their time. The list really could go on and on, but we will come back to some of his endeavours in the pages to come.

Vasari, ever keen to present a neat and uncomplicated story, wrote that da Vinci 'cultivated his genius so brilliantly that all problems he studied he solved with ease'. That was simply not the case. He pursued many of his interests for years on end without making the breakthroughs he desired. We might also wonder how he could operate across so many subject areas and retain an orderly mind. The answer, for part of the time at least, was that he didn't. But the maelstrom of ideas and thoughts racing through his head sometimes threw up the unexpected solution he was after. In his own words, 'confused things kindle the mind to great inventions'. Just as confusion could be an unexpected friend, so necessity was a more

familiar companion to the inventor: 'Necessity is the mistress and guide of nature. Necessity is the theme and the inventress, the eternal curb and law of nature.' It was a very close paraphrasing of Plato's assertion in Book II of *The Republic*: 'and yet a true creator is necessity, which is the mother of our invention'.

Da Vinci was a man of his time and inevitably some of his science does not stand up to modern scrutiny. We may raise an eyebrow, for instance, at his efforts at alchemy, which he carried out in his later years, not least after he began working for Giuliano de' Medici – a man noted for his touching faith in the pseudo-science. It is said that da Vinci donned a startling pair of blue, goggle-like spectacles for his metallurgical experiments, an adornment that contributed towards an increasing reputation for eccentricity in his old age. Yet, well over 500 years on, da Vinci as an innovator merits no derision. He was stunningly far ahead of his time (we are still catching up with him in certain respects) and to mock his endeavours only makes the one who scorns him look silly.

Bülent Atalay, author of *Math and the Mona Lisa: The Art and Science of Leonardo da Vinci*, neatly summarized it: 'So many of the insights and inventions of the notebooks prefigure the developments and discoveries of the following three hundred years. Had they been available to others in da Vinci's time, the progress of science and technology would have been accelerated dramatically.'

THE LAST SUPPER

> 'Leonardo brilliantly succeeded in envisaging and reproducing the tormented anxiety of the apostles to know who had betrayed their master.'
>
> GIORGIO VASARI ON *THE LAST SUPPER* IN *LIVES OF THE ARTISTS*, 1568

The Last Supper is one of da Vinci's two most famous paintings, despite the fact that today only about 20 per cent of his original work survives. When da Vinci finished it, it was an aesthetically astonishing piece that imbued the scene from Christ's life with a level of drama no other artist had come close to achieving. It was also a technically bravura masterpiece, employing da Vinci's hard-earned understanding of perspective to magnificent effect. If that were not enough, he also set out to rewrite the long-established rules of fresco painting so that he might better realize the image of his imagination. However, this last innovation went horribly wrong so that the painting started to degrade within a few years of its completion – a process that no one has been able to satisfactorily address. *The Last Supper* thus serves as a lesson in how da Vinci's bravery and determination to experiment reaped the greatest rewards but sometimes came at a hefty cost.

Virtually everything about the picture was radical. To begin with, the composition was unorthodox. Tradition had it that the subjects of *The Last Supper* were positioned

in a straight line behind a table, silent and often looking straight out at the viewer. Judas was usually set off to one side on his own to signify his isolation as the betrayer of Jesus. For centuries, artists of religious subjects had been bound by traditions and expectations but da Vinci had other ideas.

He approached the subject as a moment of extreme drama. This is an absolutely pivotal moment in the story of Christ's life and the whole history of the Church. Jesus's original band of devoted followers is about to be shattered by the news that one of their number has turned against the Messiah. Is it likely they would have received the news in a static line, peering out into the middle distance? Da Vinci wanted to fill the image with the sense of movement and emotional upheaval that must surely have accompanied Jesus's revelation. So he adopted a new compositional approach that brought new vitality.

At the centre of the table is Jesus, his arms outstretched, his eyes downturned, his gaze sad and regretful. The Apostles, meanwhile, are divided into four groups of three, their faces etched with emotion – shock, horror, confusion, fear, anger – as they attempt to process the news and establish which of them is guilty of the terrible crime. Not only does the history of Christianity hinge on this moment, but we have a 'whodunnit' into the bargain. Da Vinci's own notes indicate how he wanted to capture the sense of suspense: 'Another twisting the fingers of his hand together, turns with stern brow to his companion, and he with his hands spread shows the palms and shrugs up his shoulders to his ears, and makes

a mouth of astonishment.' This was art reimagining the scriptures and bringing them to life. Art demanding a raw emotional response from its audience. As Kenneth Clark described it, the work is 'the most literary of all great pictures'.

There was a further challenge to overcome. Da Vinci knew that the image was to be painted a significant height above the ground. He wanted the scene to appear as if happening in an extension to the Refectory, the wall of which it adorned in the church of Santa Maria delle Grazie in Milan. He used all his knowledge of perspective and bent the rules accordingly in order that the viewer would take in the scene as if at eye-level despite its elevated position.

Da Vinci began work on *The Last Supper* in 1495. There was an added element of pressure because Ludovico Sforza wanted to be buried in the church. The duke was da Vinci's chief patron and this was not a project that anybody wanted to go wrong. According to contemporary reports, da Vinci devoted all available hours to the project, agonizing over every detail from the physical arrangement of the figures to how best to express their emotions and by what means to apply the paint. It provided him with every bit as much 'agony and ecstasy' as Michelangelo experienced working on the Sistine Chapel.

Not that everybody was sympathetic to his efforts. The church prior, for example, was soon exasperated by the lack of evident progress on the piece (da Vinci's habit of staring at the work for hours in contemplation did not

help matters). Then, in 1496, da Vinci felt compelled to draft a letter to the duke (we do not know if it was sent) in which he complained bitterly at being distracted from his primary task to work on other projects (probably decorating work in the ducal accommodation). 'It vexes me greatly,' he wrote, 'that my having to earn my living has forced me to interrupt the work and to attend to lesser matters instead of following up the work which your Lordship entrusted to me.' Such outbursts were rare from da Vinci, especially to such valued patrons as Sforza, so we can imagine the stress he was under.

As if the challenges of the subject matter were not enough, da Vinci determined to go with his new method of fresco painting, despite it being untried in any meaningful way. Rather than using tempera to paint on to wet plaster, he concocted a mix that included oil paint and varnish. The idea was to paint on to dry plaster. The advantage was that he could later revisit the work and amend it as he saw fit. This made the painting process slower than traditional fresco work but he was sure the rewards would be there for all to see.

Da Vinci finished the masterpiece in 1497 and it was an immediate hit. Everyone who saw it was knocked out by its dramatic impact. Vasari marvelled at 'the incredible diligence with which every detail of the work was executed' and described how the 'texture of the very cloth on the table is counterfeited so cunningly that the linen itself could not look more realistic'. Yet it was soon evident that there was a problem with the paint he had used as it started to flake. Within twenty years or so

the picture had significantly degraded. By the time he was writing in the 1550s, Vasari described it as being a mere 'muddle of blots'. More indignities were to befall the work. In the mid-seventeenth century, part of it was removed to make way for an enlarged doorway; in the early eighteenth century Napoleon's troops used the refectory as a stables; and in 1943 it narrowly avoided total destruction when the Allies bombed the building. Several restorations, the last major one coming in 1976, have returned mixed results.

In the early twenty-first century *The Last Supper* entered the consciousness of a new generation as the picture at the centre of Dan Brown's mega-bestselling novel, *The Da Vinci Code*. In brief, the novel (and it is worth remembering it is a work of fiction) contends that the Holy Grail of legend is not a cup or dish used at the Last Supper but is in fact Mary Magdalene, whom the novel contends was Jesus's wife and bore him a child. Leonardo da Vinci, so the story continues, was a member of a covert organization, the Priory of Sion, charged with keeping the secrets of the Grail. It is suggested that da Vinci used his painting to transmit the great secret. The key allegation is that the figure traditionally interpreted as being the Apostle John is in fact Mary, separated from Jesus by a V-shape said to denote the 'sacred feminine'.

The tale is certainly appealing in its conjoining of religious iconography, Grail myth, Renaissance artistry and grand conspiracy. However, a great many serious students of da Vinci are sceptical of its veracity to say the least. Firstly, there is no credible evidence that da Vinci

was a member of the Priory of Sion, an organization that was most likely conjured up as a twentieth-century hoax. But *The Da Vinci Code* really pivots on whether we concede that John is in fact Mary. It is true that da Vinci's John has a certain feminine quality. Unlike most of the other disciples, he is beardless. His lustrous hair flows around his shoulders, his features are delicate and his complexion enviable. To a modern, untrained eye, it is easy to imagine that this might be a woman. However, that is not proof of da Vinci's intention. During his lifetime there was a tradition of portraying John as young and without facial hair – sometimes he was even shown as a child. Furthermore, da Vinci was in the habit of depicting men as androgynous and had an eye for male models (including his long-term companion, Salai) who were, not to put too fine a point on it, effeminate.

Code or no code (and this author suggests the latter), *The Last Supper* was an immense labour of love. In creating it, da Vinci moved Western religious art on leaps and bounds at a stroke. Rather than the staid and static iconography favoured by the Church up to this point, da Vinci honed in on a moment of high drama and infused it with emotional tension. Through stunning use and adaptation of perspective and his extraordinary evocation of human feeling, he brought the scriptures to vivid life in a wholly new way. That his experiments with fresco painting have left us with only the bare bones of his extraordinary work is nothing less than a tragedy and a hard-earned lesson that innovation can be a double-edged sword.

Imagine the Impossible

'His hands, for all their skill, could never perfectly express the subtle and wonderful ideas of his imagination.'

GIORGIO VASARI IN *LIVES OF THE ARTISTS*, 1568

Like all the truly great innovators, Leonardo da Vinci was also a visionary. All the experimentation, risk-taking and tinkering was directed towards the fulfilment of grand dreams. As da Vinci himself once noted: 'I want to work miracles.'

He had the benefit of working with men of similarly expansive aspiration from a young age. For instance, in 1471 he was part of the team that was charged with fitting an orb atop Florence's magnificent Duomo. It was a challenge of gargantuan proportions in which the orb – 8 feet across and weighing some 2 tonnes – was raised to the pinnacle, 350 feet in the air. The Duomo itself was nothing less than the stuff of dreams, an unqualified architectural triumph designed by Filippo Brunelleschi. Finished in 1436, the Duomo is the centrepiece of the city's Cattedrale di Santa Maria del Fiore and was at the time the largest self-supporting dome in existence. Such was Renaissance Florence, a city where it was permitted to imagine the impossible – the perfect breeding ground for a mind such as that of da Vinci.

So it was that he felt free to explore the boundless depths his consciousness. Apart from the many remarkable

schemes we have already mentioned, there were countless more besides – from the relative mundanity of designs for windmills and spinning wheels to the pure sci-fi of a fully operational humanoid automaton. The latter, a knight in armour, was premiered in Milan in 1495 and was able to stand, sit up, move its arms and lift its visor. It has been claimed as the prototype of a programmable analogue computer, an accolade that emphasizes just how far ahead of his time da Vinci was.

He was also one of the greatest exponents of the thought experiment to have ever lived. He was able to form a hypothesis or develop a complex principle in his mind and then think through how it may be actioned and what may be the consequences. This allowed him to go to the expense and trouble of practically testing only those ideas that had withstood the probing of the thought experiment. In other words, da Vinci was able to imagine that which others could not, before making a reasoned judgement as to whether the 'impossible' might be possible after all. As Vasari put it, 'He explained that men of genius sometimes accomplish most when they work the least; for, he added, they are thinking out inventions and forming in their minds the perfect ideas which they subsequently express and reproduce with their hands.'

Da Vinci realized more of his wondrous ideas than all but a tiny proportion of humanity. Other ideas that he was unable to bring to fruition have been taken on and developed by subsequent generations, leaving a legacy surely unrivalled in history.

THE FASCINATION OF FLIGHT

'A bird is a machine working according to mathematical laws. It lies within the power of man to reproduce this machine with all its motions, but not with as much power ... Such a machine constructed by man lacks the spirit of the bird, and this spirit must be counterfeited by the spirit of man.'

LEONARDO DA VINCI, WRITING
IN HIS NOTEBOOKS

When seeking evidence of da Vinci's uncanny vision, it is difficult to look beyond his work on human flight. It was a feat that, to the best of our knowledge, he never realized in practice but the principles he established were so sound that they were evident in the aeronautical revolution of the twentieth century.

Flight was a subject that enchanted him for a large part of his life and featured in at least nine of his notebooks. In later life, he revealed that his earliest memory was of a bird – a kite, to be specific – flying to his cradle, prising open his mouth with its tail and beating it against the inside of his mouth. Whether this was a real memory or a dream is unclear. There are myriad interpretations too, including a Freudian reading that links it to the memory of breastfeeding by his mother. But we are left with the fact that da Vinci's first memory is of a flying creature. As

a boy his interest was also piqued by the story of Icarus, the figure from Greek mythology who sought to fly but plunged to his death when the wax holding his wings of feathers together melted in the heat of the sun.

In due course, da Vinci's notebooks would be littered with assorted references to birds. They crop up in his fables and in pictograms, for instance, as well as in studies of physiology and aerodynamics. His first known drawing of a flying machine dates from 1478–80 and can still be seen at the Uffizi Gallery in Florence. It features on a page of drawings and is little more than a doodle showing a cockpit with wings and a tail, along with a mechanism to move them.

By 1485 he had designed something that is recognizably like a modern parachute. It consists of a linen canopy in the shape of a pyramid, measuring some 7 metres across and 7 metres deep. It was a design he believed would allow a man to 'throw himself down from any great height and not hurt himself' but it does not seem to have been tested in da Vinci's lifetime. One suspects there wouldn't have been queues round the block to be a guinea pig. Nonetheless, in 2,000 a version was manufactured, using canvas rather than linen, and tested from 10,000 feet. Although very heavy by the standard of modern parachutes (and non-collapsible, leaving the jumper somewhat vulnerable), it nonetheless worked.

Also around the mid-1480s, he was exploring his ideas for mechanized flight. These included a large aerial screw, several metres in diameter, and constructed from wire, reed and linen. A helix design, it formed part of his

investigations into making an improved propeller and he suggested that, if it was built big enough, it would be able to lift itself off the ground. It can thus be regarded as a prototype of a helicopter. It would not be until the 1920s that serious progress was made towards manufacturing a commercial helicopter.

DaVinci came to believe that man's best chance of flying was to build a machine that replicated the physiology and mechanics of a bird. In the late 1480s he wrote:

> See how the beating of its wings against the air supports a heavy eagle in the highly rarefied air ... So a man with wings large enough, and duly attached, might learn to overcome the resistance of the air, and conquer and subjugate it, and raise himself upon it.

In the years to come he would devise several different designs, using wings with wooden frames, a cloth 'skin' and 'muscles' made from leather. His engineering innovations included all manner of pulleys, cranks, wheels and shock absorbers. He came up with various adaptations of ornithopters – flying machines that incorporate flapping wings – that looked like fantastical, giant beasts (the vertical take-off version resembles a dragonfly) and required launch pads. He also has advice for potential pilots:

> Man when flying must stand free from the waist upwards so as to be able to balance himself as he does in a boat so that the centre of gravity in himself

and in the machine may counter-balance each other
and be shifted as necessity demands for the changes
of its centre of resistance.

Around 1500 he laid out plans for a glider, with wings
like those of a bat. 'Remember,' he wrote, 'that your flying
machine must imitate no other than the bat, because the
web is what by its union gives the armour, or strength to
its wings.' To have conjured up such brilliant designs that
were rooted in largely sound principles at a time when
the idea of flying was most commonly associated with
witchcraft is mind-boggling.

In 1505 he drew many of his ideas and principles
together in his *Treatise on the Flight of Birds*. Among its
many brilliant insights, he made a remarkable claim: 'The
big bird will take its first flight above the back of the
Great Cecero, filling the universe with amazement, filling
all the chronicles with its fame, and bringing eternal glory
to the nest where it was born.' This is widely interpreted
as being an advertisement for a planned test flight from a
large hill, Monte Ceceri, north of Florence.

Had the test flight been carried out successfully, we
would doubtless have known about it. Da Vinci, though,
included only partial designs of the machine to be trialled,
which may have been his way of making sure his plans
didn't slip into the wrong hands. Curiously, there are
no records of the test but the mathematician, Girolamo
Cardano, later claimed da Vinci 'tried to fly and failed'.
Cardano would have been just shy of his teens when da
Vinci was present in Milan so it might just be possible

that he had heard first-hand accounts of a test.

It is appealing to ponder why flight held such a fascination for da Vinci. Some academics argue it suggests some Freudian fear of falling. Yet da Vinci was a man prepared to take risks and squarely faced his share of falls. One suspects his reasons were rather more positive. Ask a room full of people today to name the superpower they would most like to possess, and a good many will respond with the ability to fly. It is tempting to think this was da Vinci's motivation, too. What greater freedom is there than to soar above the world and escape its petty trials and concerns – literally, to rise above it all. Da Vinci had a mind that was continually soaring away into the heavens. It is only natural, surely, that he dreamed that one day his body might follow.

Figure It Out: Da Vinci the Mathematician

'There is no certainty in sciences where one of
the mathematical sciences cannot be applied or
which are not in relation with these mathematics.'

LEONARDO DA VINCI, WRITING
IN HIS NOTEBOOKS

Albert Einstein once said: 'Pure mathematics is, in its way, the poetry of logical ideas.' It is a sentiment with which Leonardo da Vinci would no doubt have concurred. Both men regarded maths as a means to explain our world and universe, using a language (the language of numbers) unencumbered by emotion, bias or prejudice. Mathematics is, we might say, the pure language of truth.

The discipline of mathematics underpinned all of da Vinci's professional endeavours and intellectual pursuits. It was a fact he was proud to proclaim, as when he wrote: 'Let no man who is not a mathematician read the elements of my work.' It is there in his art – in the ratios he used to paint the *Mona Lisa*'s face, in the carefully worked perspective of *The Last Supper*, and in the dimensions of the Sforza horse as he sought to battle gravity. And again, in his scientific pursuits – da Vinci the anatomist, the flight pioneer, the architect, the naturalist, the designer of siege engines and kitchen gadgets and so on. Above all, he prized mechanics, which he called 'the Paradise of mathematical science, because here we come to the fruits of mathematics'. The 'instrumental or mechanical science', he argued, are 'of all the noblest and the most

useful, seeing that by means of this all animated bodies that have movement perform all their actions.'

Even as we struggle to pin down da Vinci, maths remained his constant companion. It offered, he said, 'the supreme certainty', allowing him to aspire to comprehend and reproduce the harmony and proportion evident in the natural world. On another occasion he described the mathematical sciences as the place 'in which truth dwells and the knowledge of the things included in them'.

It is thus all the more remarkable to remember that da Vinci was largely responsible for educating himself in the subject. The maths education he received as a child hardly extended beyond rudimentary arithmetic. Under his own steam, he immersed himself in the teachings of the great mathematicians from both his own time and throughout history. He devoured the works, for example, of Euclid, the Greek mathematician of the fourth century BCE whose history of mathematics has remained a standard text until the present day. By the end of his life, da Vinci devoted great effort to attempt to solve some of the most challenging mathematical problems of all time. We know, for instance, that for a time he believed he had resolved the conundrum of finding a square and a circle of identical area. This is, it turns out, a mathematical impossibility and we can imagine his disappointment as he realized his workings were slightly awry.

Of the great mathematical minds of his own time, he was closest to Fra Luca Pacioli, a former accountant (and pioneer of the double-entry method of bookkeeping) who had become a monk and wandering scholar. Da

Figure It Out: Da Vinci the Mathematician

Vinci was familiar with his landmark work *Summa de arithmetica, geometria, proportioni et proportionalita* (*Summary of arithmetic, geometry, proportions and proportionality*) and they struck up their friendship in Milan in 1496. It is thought possible that da Vinci was responsible for the invitation Pacioli received to visit the city in the first place. Da Vinci duly became his student and, in time, a close companion. Their admiration was mutual and Pacioli asked da Vinci to provide the drawings and diagrams for his magnum opus, *De Divina proportione* (*On the Divine Proportion*). So it is that Pacioli gave da Vinci the opportunity to add 'book illustrator' to his list of credits.

Da Vinci produced an exquisite set of geometric engravings, encompassing all manner of regular and irregular polygons. These were reproduced in the printed version of the book, which appeared in 1509 and credited the illustrations to 'that most worthy painter, perspectivist, architect, musician and master of all accomplishments'.

There is the intriguing possibility that da Vinci's friendship with Fra Luca Pacioli inspired him to establish an informal academy, bringing together Milan's greatest intellects. There exists a knot design by da Vinci under which are inscribed the words 'Academy of Leonardo da Vinci'. No one has yet proved whether this geometric emblem was the insignia of a real organization or whether it simply indicated an aspiration of its creator. In the early seventeenth century, a writer named Giralmo Borsieri referred to the 'Sforza academy of art and architecture' and claimed he had been present at a series of lectures on subjects including mechanics, architecture and perspective,

given from notes credited to da Vinci. We know that da Vinci inhabited a rich social circle that included poets, architects, artists, theologians, astrologers, doctors, engineers and inventors. Might they not have held 'talking shops' under the aegis of an academy?

We get a sense of da Vinci's enduring commitment to his mathematical studies from a letter written in the early 1500s to Isabella d'Este by an intermediary, Fra Pietro Novellara. D'Este was at the time intent on agreeing a commission with da Vinci, who had already painted her portrait. He, though, was less keen to be pinned down in her employment. Novellara had the thankless task of explaining the situation to d'Este without incurring her wrath. He blamed maths: 'his mathematical experiments have distracted him so much from painting that he cannot abide the paintbrush'.

It is perhaps fitting then that da Vinci was still working on mathematical puzzles in his notebooks when death stole upon him in 1519.

Get to the Heart of the Matter: Da Vinci the Anatomist

'How could you describe this heart in words
without filling a whole book?'

NOTE BY LEONARDO DA VINCI NEXT TO ONE
OF HIS ANATOMICAL DRAWINGS

Leonardo da Vinci arguably made his greatest mark as a scientist in the field of anatomy. It was as an atomist that he reached his peak as a seeker of truth, ready to dismiss misconceptions and superstition out of hand. The result was the most comprehensive investigation of human physiology hitherto documented, illustrated with drawings that are of major scientific importance and beautiful too.

Not only did da Vinci's skills as artist and scientist unite in his anatomical work, but his interest was inspired by a mixture of desire for scientific knowledge and a wish to improve his skills as a painter. The discipline fed into his fascination with geometry, proportion and mechanics (why are we built as we are, and how do we move and work?), philosophy (why do we think and feel as we do, and what is the relationship between body and soul?) and aesthetics (why do we look as we do?). In addition, he believed that he could better paint a living thing if he intimately understood how it was built.

Verrocchio probably began the process of instilling in his pupil a fascination with anatomy and da Vinci eagerly took up the mantle. Consider the following advice to aspiring painters:

Know which nerve or muscle is the cause of each movement and show those only as prominent and thickened and not all over the limb so that you would think you were looking at a sack of walnuts rather than the human form, or a bundle of radishes rather than the muscles of figures.

Similarly, he noted under a drawing of the nerves in the neck and shoulder: 'This demonstration is as necessary to the good draughtsman as is the origin of words from Latin to good grammarians.' He was as good as his word, too. If you are to look at his painting of St Jerome, it is easy to see how da Vinci's understanding of the musculature of the neck and shoulders has influenced his drawing of the figure.

Although his studies started while he was an apprentice in his teens, da Vinci did not begin compiling the great part of his notes on anatomy until the 1480s. As well as looking at real-life subjects, he was also influenced by the teachings of Aristotle and Hippocrates, among others. By the late 1480s he had in mind an entire volume on human anatomy, to be called *De figura umana* (*Of the Human Figure*). By then his desire was to know everything that could be known about the body, from the workings of the brain and limbs to the mechanics of how we raise an eyebrow and frown, why we sneeze and yawn, what makes us feel hungry or lustful, and how paralysis strikes.

In time he would identify what he described as 'eleven elementary tissues' – cartilage, bones, nerves, veins and arteries, fascia, ligaments and sinews, skin, muscle and fat.

He carried out vital new research in relation to all of them. For instance, he documented the muscles of the body as never before. Over time he gained an unprecedented understanding as to how the limbs, joints and musculature act like a series of levers, hinges, pivots, gears and winches.

In the field of optics, meanwhile, he wrote a treatise in 1508 that categorically showed the eye as a receptor of light rather than as a mysterious organ of quasi-mystical qualities that the world at large then believed it to be. He also did a good degree of myth-busting in the area of neuroscience, even if not all of his conclusions stand up to modern analysis. He produced, for example, a detailed series of drawings of the skull, in which he highlighted the *sensus communis*. This, he believed, was where the senses met and sensory information was processed. As he put it: 'The common sense is what judges the things given to it by the other senses. The ancient speculators concluded that man's capacity to interpret is caused by an organ to which the other five senses refer everything ...' He was now convinced that common sense was 'not all-pervading throughout the body, as many have thought'. He was essentially seeking to show empirically the location of the hub of imagination and intellect or, to put it another way, 'the seat of the soul'.

This is merely to scratch at the surface of da Vinci's achievements. He also, among other things, rewrote our understanding of the relationship between a mother and a baby in the womb, realized that the heart is responsible for pumping blood around the body (as opposed to being the abode of the soul), and used the lost-wax method

of mould-making to take plaster casts of the cavities of the heart and brain. Furthermore, he established a handy set of anatomical 'rules of thumb' that were particularly useful to the artist and the student of proportion. So, for example, he laid down the following:

- Every man, at three years old, is half the full height he will grow at last.
- The foot is as much longer than the hand as the thickness of the arm at the wrist where it is thinnest seen facing.
- The space between the extreme poles inside and outside the foot called the ankle or ankle bone is equal to the space between the mouth and the inner corner of the eye.
- A man when he lies down is reduced to one-ninth of his height.

As we might expect, he sought to gather the knowledge of the leading academic names in the field. Vasari tells us about his 'study of human anatomy, in which he collaborated with that excellent philosopher Marc Antonio della Torre, who was then lecturing at Pavia'. A great part of his expertise, however, came from his own hard graft. In particular, he executed a large number of post-mortem examinations. This was gruesome work at a time when there was no clinical, cold storage for cadavers. Furthermore, it was hugely controversial. The human body had long been considered a sacred object, so that dissection was a form of desecration. Indeed, the whole

scientific field had been held back by the reluctance of society at large (and the Church in particular) to sanction the process. Da Vinci would find himself denounced to the Pope for his endeavours in 1515.

Yet he was able to put such considerations to one side. The dead did not spook him. For evidence, we can look back to Florence in 1478. In May, an attempted putsch against the Medici resulted in some eighty public executions within the space of a few days. One of the senior figures in the coup was Bernardo di Bandino, who escaped capture for a few months. When he did fall into Medici hands, he was tortured before being hanged from a window in the middle of the city. Da Vinci, possibly hungry for a Medici commission, sketched the bloody scene and made remarkably sanguine notes of what the corpse was dressed in ('Small tan-coloured berretta; doublet of black surge; a black jerkin lined; a blue coat lined with fox fur and the collar of the jerkin covered with stippled velvet, red and black; black hose'). Da Vinci had cast himself as a witness to death, a camera showing the scene as it really was. This ability to detach himself emotionally came to the fore in his dissection work.

His commitment to anatomical study and all it entailed shines through in the following passage, written around 1508:

And you, who say that it would be better to watch an anatomist at work than to see these drawings, you would be right, if it were possible to observe all the things which are demonstrated in such drawings in a

single figure, in which you, with all your cleverness, will not see nor obtain knowledge of more than some few veins, to obtain a true and perfect knowledge of which I have dissected more than ten human bodies, destroying all the other members, and removing the very minutest particles of the flesh by which these veins are surrounded, without causing them to bleed, excepting the insensible bleeding of the capillary veins; and as one single body would not last so long, since it was necessary to proceed with several bodies by degrees, until I came to an end and had a complete knowledge; this I repeated twice, to learn the differences ...

Da Vinci was studying in Pavia under della Torre when a fellow student, Paolo Giovio, wrote of him: 'He dedicated himself to the inhuman and disgusting work of dissecting the corpses of criminals in the medical schools, so that he might be able to paint the various joints and muscles as they bend and stretch according to the laws of nature.' By 1517, da Vinci's 'body count' had risen to 'more than thirty' and ranged from children to an old man of over a hundred ('I made an anatomy to see the cause of a death so sweet').

There were, and are, those who believe that the time da Vinci lavished on anatomical study took him away from his art, which they regard as his greatest contribution to the world. It is hardly a generous appraisal. Regardless of the art he put into his anatomical drawings, he provided science with an invaluable resource, which has been used

for hundreds of years. Among his greatest innovations was his determination to provide multiple views of individual anatomical features. Sometimes he provided as many as eight different representations, including overviews, cross-sections and transparencies. As the art critic Edward Lucie-Smith described, he put 'his skill at the service of truth rather than of some ideal of beauty'.

VITRUVIAN MAN

> 'Beauty is produced by the pleasing appearance and good taste of the whole, and by the dimensions of all the parts being duly proportioned to each other.'
>
> VITRUVIUS IN *DE ARCHITECTURA*, C.15 BCE

Vitruvian Man is almost certainly the most famous drawing in the world, and is emblematic of da Vinci's extraordinary ability to fuse his scientific and artistic sides. In this one image we see his brilliance in anatomy, geometry, architecture and draughtsmanship.

The drawing, done in pen and ink around 1490, shows a man standing naked, his arms outstretched at right-angles. He is contained within a box to illustrate that a man's height is equal to his span. Superimposed is the same figure but with his legs astride and his arms raised at an angle. He is contained within a circle, to prove the assertion that a man with his legs thus parted has his

height reduced by one-fourteenth and that if his arms are raised so his middle fingers line up with the top of the head, the centre of the outspread limbs is the belly button and the space between his legs is an equilateral triangle.

These rules stem from the writings of Vitruvius, hence the image's name. Vitruvius was a Roman architect and military engineer, working in the first century BCE. His great treatise, *De architectura* (*On Architecture*) is the only technical work on architecture to have survived from the ancient world and was hugely influential on da Vinci. It had been rediscovered in 1414 by Poggio Bracciolini, a Florentine scholar, and came into the wider consciousness when Leon Battista Alberti mined it for his own treatise on architecture, written around 1450. Filippo Brunelleschi, architect of Florence's Duomo, was another to acknowledge his debt to Vitruvius.

Vitruvius argued that architecture ought to possess three main qualities: it should be solid, useful and beautiful. To this end, he believed it should reflect nature and, in particular, look to the human body for its sense of proportion – the body being the ultimate paradigm of perfect proportionality. With this in mind, he laid out various rules, stating, for instance, that four fingers make a palm, four palms a foot, six palms a cubit and four cubits a man's height. His writings were highly formative in da Vinci's development and *Vitruvian Man* relates specifically to the following passage from *De architectura:*

The navel is naturally placed in the centre of the human body, and, if in a man lying with his face

upward, and his hands and feet extended, from his navel as the centre, a circle be described, it will touch his fingers and toes. It is not alone by a circle, that the human body is thus circumscribed, as may be seen by placing it within a square. For measuring from the feet to the crown of the head, and then across the arms fully extended, we find the latter measure equal to the former; so that lines at right angles to each other, enclosing the figure, will form a square.

One of the many remarkable features of the drawing is that the face also adheres to strict rules of proportion (for instance, the distance between eyebrows and hair is the same as chin to mouth). Yet the face expresses emotion far beyond what we might expect from a geometric drawing. There is also the tantalizing suspicion that the face we see is that of da Vinci himself. Altogether, it is an epic study in harmonious proportion and a celebration of natural laws and the beauty of man.

Scale Up Your Talents: Da Vinci the Civil Engineer

'In peacetime, I think I can give perfect satisfaction and be the equal of any man in architecture, in the design of buildings public and private, or to conduct water from one place to another.'

LETTER DRAFTED BY LEONARDO DA VINCI TO LUDOVICO SFORZA, EARLY 1480S

Arguably, da Vinci's most practical application of his scientific know-how was as a civil engineer – a role in which he excelled and for which he was well rewarded. He applied his mind to solving real problems in the most efficient way possible, while maintaining a concern for the aesthetics of the projects he worked on – a rare blend still, as an eye cast over a few modern-day civil engineering schemes will attest.

From his earliest days in Verrocchio's studio, he showed a keen interest in architectural and engineering problems. He was privileged to be involved in erecting an orb above Brunelleschi's dome and the architect was a major influence on him, along with the likes of Vitruvius, Alberti and Donato Bramante. Inspired by them, da Vinci believed that architecture should be in balance. Indeed, he spoke in terms of the 'doctor-architect' who looks to the laws and proportions of nature when considering how to construct a building. (*Vitruvian Man* was a manifestation of this philosophy.)

By the late 1470s, he was designing advanced engineering machinery, including lifting devices redolent of those used by Brunelleschi in the construction of

the Duomo. He also began to refine his theories of civil engineering, devising his own system of laws. The following three observations give a taste of his evolving 'rule book':

- Let the width of the streets be equal to the average height of the houses.
- The arch is nothing else than a force originated by two weaknesses, for the arch in buildings is composed to two segments of a circle, each of which being very weak in itself tends to fall; but as each opposes this tendency in the other, the two weaknesses combine to form one strength.
- The beam which is more than twenty times as long as its greatest thickness will be of brief duration and will break in half.

Typically, he did not lack for ambition or confidence. Several times he proposed to the authorities in Florence that the temple of San Giovanni (often known simply as the Baptistry) should be lifted clean off the ground so that steps could be inserted underneath. His justification was that this would improve the look of the temple but also provide greater protection against flooding. While such a scheme was not without precedent in Italy, nothing on that scale had ever been undertaken. In the end, there was too much nervousness among the city's powerbrokers to give approval but Vasari reported that da Vinci was nonetheless successful in convincing many sceptics that he could do it.

Not that all his engineering works were quite so grand in scope. In Milan, for instance, he spent a good deal of time on what were effectively home improvements for the duke and his family. This included devising a system to better heat bathwater. While such projects no doubt proved a temporary diversion, it is difficult to believe they satisfied a mind capable of so much more. Da Vinci was no mere handyman. This was someone, after all, who was busily laying out designs for spectacular temples in his spare time.

Milan suffered an outbreak of bubonic plague in 1485, which killed up to a third of the population. It is highly likely that this prompted da Vinci to focus his mind on the question of town planning. This was, in broad terms, a discipline that looked to impose order where disorder might reign. Drawings from 1487 reveal his dreams for a city built on a geometric design. His extremely detailed schemes are filled with wide streets, buildings of regular height, public squares, loggias, a canal system for transporting goods and animals, a 'lower level' for poorer housing and an elevated pedestrian level for the wealthier. Health and sanitation were clearly of concern, with plans for extra tall chimneys to improve air quality, and even the use of spiral staircases to deter al fresco urination from upper floors. 'The seat of the latrine,' meanwhile, 'should be able to swivel like the turnstile in a convent and return to its original position by use of a counterweight. The ceiling should have many holes in it so that one can breathe.'

After leaving Milan in 1499, da Vinci's skills as a civil

engineer were in demand. He also used his travels in this period as an opportunity to hone his cartographic skills. In 1502 he drew a remarkable bird's-eye-view map of Imola that continues to confound those trying to work out how he produced it. Way ahead of its time in terms of accuracy as well as being a thing of beauty, it has even led some to suggest that da Vinci had the ability to condense time and space in order to see the world differently from the rest of us. That may sound ridiculous but there is something almost other-worldly about the map when compared to contemporary equivalents.

In 1952 a document was discovered in Turkey's state archives that seems to provide evidence that da Vinci offered his services to Sultan Bayezid II in 1503 to design and construct a bridge over the Golden Horn (an estuary at Istanbul). It shows that his ambition was as boundless as ever. At 1200 feet, the bridge would have been the longest then in existence. A number of drawings in his notebooks are, experts believe, connected with this proposed project. Sadly, it never came to fruition but in 2001 a version about a quarter of the size was built for pedestrians over a motorway in Norway. It was a popular success, and proved da Vinci's revolutionary scheme would have worked.

Da Vinci being da Vinci, there were failures along the way, too. Around the time that he was envisaging the bridge over the Golden Horn, he was also working on plans to divert the River Arno near Florence. This had both civil and military elements. On the one hand, Florence wanted to cut off its neighbouring enemy, Pisa, from a navigable waterway, while on the other hand the

Florentine authorities wanted their own direct canal route to the sea (not least so it could play a more active role in New World trading). The military component required the digging of a vast ditch, for which da Vinci designed various digging machines. However, in late 1504 the ditch collapsed during unforgiving storms, causing flooding that destroyed swathes of farmland. Within two months of it beginning, the project was brought to a close. This disaster, allied to the huge prospective cost of the canal, meant that da Vinci's accompanying civil scheme never got underway. Yet the civil engineer who never fails surely suffers from a lack of ambition – a charge that could never be levelled at da Vinci.

Play the Markets

'Cannot such artists keep some good work, and then say: this is a costly work, and this more moderate and this is average work and show that they can work at all prices?'

LEONARDO DA VINCI, WRITING
IN HIS NOTEBOOKS

Leonardo da Vinci was a visionary, an idealist and a perfectionist. However, he also had the good sense to understand the importance of taking care of business. He needed patronage and finance to fund his life's endeavours and he was prepared to do what was required to secure it.

The quote on page 119 comes from a longer passage that serves as testament to his sound business sense. In it, he besmirches those artists who moan and complain that they haven't been paid enough to fund their best work. Da Vinci's solution is simple: offer to produce work at a variety of price points so that the buyer knows what they will get for their money. In crude terms, a well-paying commissioner might expect a work created by da Vinci's own careful hand, while those with a smaller budget would have to make do with a piece originating from his apprentices (overseen and guided by the master). Artists had started to acquire celebrity status in the Renaissance, but theirs was still an industry in which they needed to make the margins work.

Other writings by da Vinci reveal that he was a wily operator when it came to conducting personal relationships, skills he no doubt used to woo potential clients. He counselled, for instance:

Words which do not satisfy the ear of the hearer weary him or vex him, and the symptoms of this you will often see in such hearers in their frequent yawns; you therefore, who speak before men whose good will you desire, when you see such an excess of fatigue, abridge your speech, or change your discourse; and if you do otherwise, then instead of the favour you desire, you will get dislike and hostility.

Elaborating on the theme, he wrote:

And if you would see in what a man takes pleasure without hearing him speak, change the subject of your discourse in talking to him, and when you presently see him intent, without yawning, or wrinkling his brow or other actions of various kinds, you may be certain that the matter of which you are speaking is such as is agreeable to him.

These were his timeless guidelines for launching a charm offensive. In reality, though, da Vinci's conduct was not to everyone's pleasing and he had regular disputes with patrons throughout his career. He wrote one enigmatic line that has puzzled scholars for generations since it can be translated as either 'the physicians created and destroyed me' (possibly a reference to the circumstances of his arrival into this world and subsequent failures to cure later ill-health) or 'the Medici created me and destroyed me'. If the latter interpretation is the correct one, it perhaps suggests that he credited the ruling family

of Florence with building his career before he fell into their disfavour. His relationship with Lorenzo de' Medici is ambiguous and it is unclear whether da Vinci was intent on leaving Florence for Milan in late 1481 or whether Lorenzo was keen for him to go.

Da Vinci was careful to work on new professional alliances even as older ones turned sour. Whatever the exact circumstances of his move to Milan, he did all he could to make it work for him. At this time Milan was a more populous city than Florence. Sforza, who had secured power for himself from the position of regent, was cunning, ambitious and savagely pragmatic. Hungry to maintain his powerbase while building the city's glory, he wanted to create a Renaissance hub to rival Florence. Da Vinci read his desires beautifully, pitching himself firstly as the man who could burnish Milan's military might as well as fill Sforza's court with the beautiful music he relished. Da Vinci finished his letter of introduction: 'Also I can undertake sculpture in marble, bronze or clay, and in painting I can do everything that it is possible to do, as well as any other man whoever he may be.' It was as if his artistic skills were referenced as a mere afterthought and demonstrates da Vinci's willingness to cut his cloth to suit his clients' demands.

In Milan, he was soon mixing with the city's wealthy elite, including bankers, diplomats and intellectuals. He also made friends with Milan's hitherto biggest name in art, Donato Bramante, as well as setting up advantageous working relationships with the four popular artist brothers of the de Predis family. Again, though, there is a conflict

between da Vinci the business-builder and da Vinci the artist, who got into costly and debilitating contractual wrangles with the family. Before he left Florence, he had failed to deliver a promised *Adoration of the Magi*. Now in Milan, he became embroiled in what would turn into a twenty-five-year-long battle over his share of the fee for *The Virgin of the Rocks* (the National Gallery version), which he painted with Ambrogio de Predis. The trouble came to a head when the commissioning body (the Confraternity of the Immaculate Conception) withheld part-payment owing to their dissatisfaction with the finished work.

When the French deposed Sforza and took over Milan in 1499, however, da Vinci again showed his business acumen. As a public figure closely associated with the previous regime, he was in a precarious position but it appears that he reached an accommodation with the city's new masters.

After the star of da Vinci's next patron, Cesare Borgia, faded, da Vinci returned to Florence to receive one of the biggest commissions of his career – *The Battle of Anghiari* (see page 164). With that project going seriously awry by 1506, he was given permission to make his way back to Milan to deal with contractual disputes related to *The Virgin of the Rocks*. Once in Milan, he was again seeking out the next business opportunity, undertaking work (including design of a summer villa) for the city's French governor, Charles d'Amboise. The Florentine authorities demanded his return to finish *The Battle of Anghiari*, but da Vinci did not want to go and he had the support of d'Amboise.

KEEP YOUR EYE ON THE PRIZE

Amid great instability in Milan, da Vinci ensured his own position was safe and then chose the moment to seek newer, more stable pastures. He went to Venice and then Mantua, where he wooed the city's Marchioness, Isabella d'Este, and won her patronage, before making his way back to Florence. There he found himself hailed as a returning hero and was overwhelmed with requests for work. He was able to reap the rewards of his friendliness with the French in Milan, too, with one of Louis XII's highest officials, Florimond Robertet, commissioning *The Madonna of the Yardwinder*. At the same time, he turned down persistent requests from d'Este for more work, citing prior commitments to the French king. D'Este would have been a generous, sympathetic and reliable patron but he set her aside to go after a bigger fish: Cesare Borgia. Once again, he worked his magic and got the gig.

Again, da Vinci proved himself to be a shrewd operator, securing the intervention of the French king and effectively giving the Florentines no option but to let

him stay. Their annoyance was evident in a note they sent to Milan:

> Leonardo ... has not behaved as he should have done towards the republic, because he has taken a large sum of money and only made a small beginning on the great work he was commissioned to carry out, and in his devotion to Your Lordship he has made himself a debtor to us.

Da Vinci was playing off his patrons, leaving one city under a cloud and going to another where the welcome was warm. He was then appointed Louis's 'painter and engineer in ordinary' (his permanent go-to guy, as it were). In 1507, he once more took advantage of his royal links when Louis appealed to the government in Florence to look kindly on da Vinci in the matter of litigation over his uncle's will. What was meant to be a short trip to Milan to sort out some legal argy-bargy turned into an extremely advantageous seven-year stay.

Then, in 1513, he followed his nose for business yet again, this time responding to a request from Giuliano de' Medici (the Medicis were back in political favour by this point) to join him in Rome. When Giuliano died of consumption in 1516, aged just thirty-seven, da Vinci found his services in demand from the new French king, Francis I. This proved to be da Vinci's insurance policy for his old age. Relocating to France, he lived out his final years in comfort in a manor house at Cloux and with the freedom to pursue his personal interests. There he was

fêted by the king and by numerous visitors, for whom he was something of a tourist attraction. As the sculptor Benvenuto Cellini observed, 'there were few days in the year when the king was parted from him'.

Da Vinci constructed a precarious house of cards over his long career. He left behind a string of disgruntled patrons infuriated by his sometimes cavalier approach to fulfilling contracts. Yet he never lacked for work and his reputation ensured a constant stream of aspiring new patrons. It should perhaps be considered a failure of his business strategy that he never secured a major Vatican commission of the sort enjoyed by Michelangelo and Raphael. Overall, however, he played a dangerous game quite brilliantly over many decades. Da Vinci was a dreamer, but one who knew how to play the business side of things, too.

Don't Let Money
Be Your Master

'That is not riches which may be lost; virtue is
our true good and the true reward of its
possessor. That cannot be lost; that never deserts
us, but when life leaves us. As to property and
external riches, hold them with trembling; they
often leave their possessor in contempt, and
mocked at for having lost them.'

LEONARDO DA VINCI, WRITING
IN HIS NOTEBOOKS

Despite da Vinci's commercial capabilities, he nonetheless never achieved the kind of wealth that someone of such prodigious talents might have accrued. He always managed to keep the wolf from the door (although it was on occasion a close-run thing) but he was never definitively *rich*. In the words of Vasari: 'He owned, one might say, nothing and he worked very little, yet he always kept servants as well as horses.'

This is all the more remarkable given the extraordinary value we now attach to anything that he touched (and even to those things we only suspect that he might have touched). It is difficult to put a price tag on his major works as they so rarely come up for sale, but consider some of the money he has attracted in recent years. In 2013, for example, a private buyer bought *Salvator Mundi (Saviour of the World)*, a previously lost da Vinci depicting the face of Christ. Painted on a damaged wooden panel and now generally accepted as his work, it is not regarded as a first-rate masterpiece but still went for US$75 million. Had it been in better condition, the price would likely have been two to three times higher, according to conservative estimates.

Meanwhile, his seventy-two-page notebook known as the Codex Leicester was bought for $30.8 million by Bill Gates in 1994, making it comfortably the most expensive manuscript in history when the price is adjusted for inflation. At the time many Italians were distraught that a national treasure should be sold abroad but Gates argued that it was part of our collective global cultural heritage. 'I remember going home one night and telling my wife Melinda that I was going to buy a notebook,' he would later say. 'She didn't think that was a very big deal.'

In both these cases, astronomical sums were paid for works that are not, in crude terms, the great headline-grabbers of his career. The Codex Leicester, for example, does not contain his designs for flying machines or any of his magnificent anatomical work. And the *Salvator Mundi* is no *Mona Lisa*. So what of that work? It takes a good degree of bravery to assign a value to da Vinci's most famous piece but it was reputedly insured for $100 million when it went on tour back in the 1960s. Today it would surely sell for a billion if it were ever to come to market, and perhaps much more. By way of comparison, at the time of writing the current record price for a painting at public auction is the $179.4 million paid for Picasso's *The Women of Algiers* (Version 0) in May 2015, although this is a much smaller sum than the $300 million paid for Gauguin's *Nafea faa ipoipo*, the most expensive work ever sold.

What da Vinci would have made of such figures, we can only imagine. While his father was a well-to-do notary, Leonardo's childhood was really quite humble. Nor would he receive anything in his father's will, which

left everything to his legitimate children. We also know that there were periods in da Vinci's career when he was working for payment in kind just to keep himself fed, watered and warm. In the Codex Atlanticus, a hand other than that of da Vinci – probably belonging to one of his pupils – wrote 'round here money is tight'.

The records of his departure from Milan in 1499 also point to a modest existence even at that advanced point in his career. He had two boxes made to store his possessions and specially noted that he would take three bedspreads with him, while anything else he couldn't transport was to be sold. This was no high-roller's existence – an observation backed up by a letter written after his return to Florence in 1500 by Fra Pietro Novellara to Isabella d'Este. Da Vinci's life was, he wrote, 'extremely irregular and haphazard ... he seems to live from day to day'.

Yet da Vinci seems not to have worried overly about his finances. He had enough work from suitably rich patrons over his lifetime to satisfy his needs. He was not a greatly materialistic man. His work and his intellectual development were more important to him than expensively acquired possessions. Considering da Vinci's own fortunes relied on the desire of others for ostentatious displays of wealth, he harboured no such yearnings. Indeed, in his notes he repeatedly warned against it. 'He who wishes to be rich in a day will be hanged in a year,' he wrote on one occasion, and on another: 'He who possesses most must be most afraid of loss.'

Capture Your Subject

'If one wanted to see how faithfully art can
imitate nature, one could readily perceive it from
this head; for here Leonardo subtly reproduced
every living detail.'

GIORGIO VASARI ON THE *MONA LISA*
IN *LIVES OF THE ARTISTS*, 1568

We have seen how Leonardo da Vinci approached his work in a vigorously scientific manner. However, he also brought to his artwork a quality of empathy that it is difficult to describe in terms of science. For all that we admire his use of perspective, his understanding of light and shade or the perfect proportioning of his figures, how can we explain what makes his pictures just so ... beautiful?

The answer is surely that he was able to engage with his subjects totally. In language of which he might well not have approved, he seemed to occupy their souls. *The Last Supper*, for instance, is so memorable because he shows the disciples as alive with emotion. Similarly, his drawings of grotesques are less cruel caricatures of ugliness than they are studies in the ravages of time, sadness and confusion. Da Vinci was also careful to find the perfect models for his subject matter, trawling the streets in search of just the right face. (Although legend has it that the prior who harangued him for his lack of progress on *The Last Supper* was lined up to be the face of Judas – 'a face which would be fit for this evil man'.)

Arguably his consistently most arresting work were his portraits of women. Whether in one of his several

depictions of the Virgin Mary or his paintings of real-life models (for instance, *Ginevra de' Benci*, *Lady with an Ermine* and the *Mona Lisa*), he brought his subjects utterly to life. Contemporary accounts suggest he was able to capture the likeness and the essence of his sitters perfectly. His women are frequently beautiful but they are never just pretty objects at which to gaze. We famously talk about the enigmatic smile of the *Mona Lisa*, suggestive of some secret delight that we can never quite grasp. Yet all of his portraits hint at the interior lives of their subjects.

He achieved, for example, an extraordinary level of emotional engagement in his first known portrait, of the seventeen-year-old Florentine banker's daughter, Ginevra de' Benci. Truly, we feel like we are looking at a real, young woman as if through a window, her gaze suggesting she is deep in thought. Of what her young mind is dreaming remains, of course, tantalizingly elusive.

Similarly, *Lady with an Ermine* captures its subject as she seemingly spontaneously casts her eyes off to her left. Her face is a study of vitality and intelligence. Indeed, the subject – Cecilia Gallerani – was renowned for her intellect and love of culture in the court of Ludovico Sforza. She was the duke's mistress too, and it was he who commissioned the portrait. Might it be to her lover that she has turned her gaze? Da Vinci manages to convey the simmering sexual intrigue – there is the gentlest hint of bosom, while the hand stroking the ermine is erotically suggestive – without ever turning her into merely an object of desire. She is beautiful but this woman, we can be sure, is no pushover.

That da Vinci was able to convey the multilayered complexity of his female subjects is likely a reflection of his own complicated relations with the opposite sex. As we shall see in due course, it is unlikely that da Vinci was sexually attracted to his female sitters yet there is a sense that he *loved* women. Over his career he explored femininity in his paintings time and again, but it is believed he painted only one portrait of a living male subject (*Portrait of a Musician*), and that may have been a self-portrait. It is also notable that he regularly excluded Joseph from his depictions of the Virgin and Child. This may be suggestive of a rejection of male authority figures related to his unsatisfactory relationship with his father.

Yet his relationship with his mother could hardly be described as straightforward either. We know that between 1493 and 1495 da Vinci's household included a woman named Caterina. Logic would suggest this was his mother, coming to live with her son in her old age. His notes at this time reveal his ambiguous feelings toward mother figures, as when he wrote: 'In some animals Nature seems a cruel stepmother rather than a mother; and in others not a stepmother but a tender mother.' Another note urged 'do not be a liar about the past' – perhaps an exhortation to his mother.

This complicated mix of emotions seems to have manifested itself in a desire to reach out to his female subjects and to explore their multifaceted characters. His paintings at once idealize the feminine form without ever reducing the women to mere ciphers for traditional female attributes. They are living, breathing people, their

faces alight with intelligence and their expressions often deliciously inscrutable.

THE MOST FAMOUS PAINTING ON EARTH

'Mona Lisa looks as if she has just been sick, or is about to be.'

NOËL COWARD

They say that familiarity breeds contempt, and that perhaps explains Noël Coward's observation above. For the fact is, the *Mona Lisa* is the most famous and reproduced painting in the world – a status that has obscured our collective view of the picture itself. Just as da Vinci has become almost a symbolic presence in our culture, so too his most celebrated work. So why is the *Mona Lisa* so well known?

The question is not a simple one. Is it the greatest picture ever painted? Many critics would dismiss the notion of such a title as ridiculous. There are those who doubt it is even da Vinci's finest portrait. So was it somehow revolutionary? Yes and no. Da Vinci employed many of his greatest innovations in its production but these are evident in other works, too. Its fame, though, is perhaps best explained as the result of a 'perfect storm' of circumstances.

Let's go back to basics. The *Mona Lisa* was painted in oil on a panel of white Lombardy poplar and measures

30 by 21 inches. Da Vinci began working on the picture in 1503 and still had it in his possession at his death, when it was passed to his lifelong companion, Salai, before being bought by the king of France. The question as to the identity of the sitter is surely the most debated mystery in art history, although it seems likely that we can ultimately take the word of Vasari on this subject. He claimed it was commissioned by a Florentine merchant, Francesco del Giocondo, who wanted a portrait of his twenty-four-year-old wife, Lisa (born Lisa di Antonmaria Gherardini). For some, it is a grave disappointment that the image is of an 'ordinary' woman, rather than some more mysterious or celebrated figure. For others, it only adds to the charm.

It seems that da Vinci returned time and again to the piece for a decade at least, retouching and reworking it. The *Mona Lisa*'s famous hands, meanwhile, were first seen in his portrait of Isabella d'Este around the turn of the century. The picture also represents a high point in da Vinci's use of *sfumato*. He arguably never bettered the composition either, and the background is rendered beautifully so as to create real atmosphere. Then, of course, there is Lisa's face and *that* smile. There is no denying that this is a masterpiece, and that da Vinci retained it all those years suggests he believed so, too.

And yet ... It was only in the nineteenth century that the *Mona Lisa* (or in Italian, *La Gioconda* – or 'the happy one' – a pun on the purported sitter's married name) became *the* picture that the world knows. This was partly thanks to an upsurge of interest in the Renaissance across Europe in general and in France especially. The *Mona Lisa*

lived then, as now, at the Louvre in Paris and so became an object of pilgrimage for art lovers. Furthermore, Lisa's expression was something of a turn-on for a certain breed of nineteenth-century man bewitched by such subtle female allure.

Then, in 1911, the painting was sensationally stolen from under the noses of museum security. It was taken by a disgruntled Italian employee, Vincenzo Peruggia, who believed the work should reside in da Vinci's homeland. He walked out of the Louvre with it hidden under his coat and kept it in his flat for two years, until he was caught trying to sell it to the Uffizi. By then there was no more famous picture in the world, and its reputation has only grown since. Safely restored to the Louvre (and now kept behind bulletproof glass), the picture is viewed by some 6 million visitors a year, who spend an average of about fifteen seconds looking at it.

As for that enigmatic smile, in 2005 a team from the universities of Amsterdam and Illinois analysed Lisa's expression using facial-recognition software. The programs determined that she is 83 per cent happy, 9 per cent disgusted, 6 per cent fearful and 2 per cent angry. In truth, though, we will never know for sure just what is behind that most famous smile.

Perfectionism Can Be a Flaw

'So many of his works remain unfinished.
The truth, however, is surely that Leonardo's
profound and discerning mind was so ambitious
that this itself was an impediment; and the reason
he failed was because he endeavoured
to add excellence to excellence and
perfection to perfection.'

GIORGIO VASARI IN *LIVES OF THE ARTISTS*, 1568

While Leonardo da Vinci bequeathed an extraordinary legacy that it is hard to criticize, it is noticeable just how few of his works were ever completed. This was, according to some sources, the greatest regret of his own life and leaves us with a lingering sense of just what might have been. Vasari's comment on page 138 is particularly apposite because da Vinci's relentless pursuit of perfection across so many disciplines could sometimes be his downfall.

He also had an unfortunate penchant for losing interest in projects before they were finished. In his painting, he seemed to derive greatest joy from the early stages of a commission, when he would ponder how to compose a scene, what background to include and how each figure would look. The job of applying paint to bring his cartoons to life was much less appealing. Nor did he believe in hurrying a work, believing it would take as long as was required. This inevitably brought him into conflict with those paying good money for his labour and who were unwilling to entertain every whim of the artist.

Da Vinci never lacked for confidence in his abilities. Take his letter of introduction to Sforza in Milan: 'I can carry out sculpture in marble, bronze and clay; and in

painting can do any kind of work as well as any man, whoever he may be.' However, his unreliability when it came to delivering commissions was there from the start. His very first commission as an independent artist, received in January 1478 to paint an altarpiece for the Chapel of San Bernardo in Florence, was never fulfilled, despite it being a highly prestigious job. His life would go on to be beset by contractual disputes, as has already been described. Vasari spoke of the young Leonardo as 'volatile and unstable', traits he never quite overcame. While his uncompromising pursuit of perfection made him the artist he was, it also impeded his ability to deliver work to order.

THE SFORZA HORSE

'Moreover, the bronze horse could be made that will be to the immortal glory and eternal honour of the lord your father of blessed memory and of the illustrious house of Sforza.'

LEONARDO DA VINCI'S LETTER OF INTRODUCTION TO LUDOVICO SFORZA

The Sforza horse (sometimes known as *Gran Cavallo*) should have been a crowning achievement in da Vinci's remarkable career, and his greatest triumph as a sculptor. As things turned out, it became one of those arduous projects that peppered his life, promising so much but failing to quite deliver. It may be viewed as the classic example of his ambition outstretching the achievable.

Perfectionism Can Be a Flaw

For many years, Ludovico Sforza had harboured a desire to create a huge, awe-inspiring bronze statue of a figure on horseback in tribute to his father Francesco, the former Duke of Milan. In 1489 he gave the commission to da Vinci. From the outset, however – according to Pietro Alamanni, Florence's ambassador in Milan – Sforza was 'not confident that he will succeed'. Da Vinci, we can see, had already earned himself a reputation for questionable reliability in the eyes of one of his greatest patrons.

Nonetheless, he set about the task in hand with great energy. His preparatory drawings for the sculpture were things of beauty born of the artist's lifelong fascination for horses and equestrianism. His initial vision was to create something never before seen – a giant, bronze horse rearing up on its hind legs. Da Vinci attempted to devise a way of supporting the vast weight of bronze needed. One idea was to depict a fallen enemy lying on the ground so that the vanquished figure might provide additional support, but in practice it would not have worked.

Da Vinci compromised, reworking his drawings to show a horse in a more traditional trotting pose. His plan was to build a full-size model of the horse (which was to be about three times life-size), then use that to create a mould that would be used to cast the bronze statue. The clay model was complete by 1493, when it was put on display during the marriage of the duke's niece to the Holy Roman Emperor. According to Vasari: 'Those who saw the great clay model that Leonardo made considered that they had never seen a finer or more magnificent piece of work.'

Some 75 tonnes of bronze were put aside for the final casting before disaster struck. By 1494 Milan was living under the threat of a French invasion. Grand artistic gestures were fine in times of peace, but practical demands now took over. The bronze for the horse was requisitioned to be made into arms and the Sforza horse was abandoned once and for all. Da Vinci's desire to make bigger and better than had ever been made before ultimately resulted in the failure of the project. His own unstinting ambition had stymied him.

To add insult to injury, even the clay horse (doubtless a wonder in itself) was destroyed when occupying French troops used it for target practice in 1499.

Keep Your Friends Close

'He was so generous that he sheltered and fed all his friends, rich or poor, provided they were of some talent or worth.'

GIORGIO VASARI IN *LIVES OF THE ARTISTS*, 1568

After Leonardo da Vinci's early years were at least partially defined by parental rejection, in adulthood he maintained just a few close friendships while seemingly keeping a guard of his innermost emotions.

It was not that da Vinci was antisocial. Quite the reverse. He was adept at establishing himself in city after city, winning new patrons wherever he went. He was also a regular on the social circuits of those cities, partaking in a cultural exchange with what today we would call other 'creatives'. All of which is to say that he had a reputation for being someone people liked to be around. He was, according to most accounts, a good conversationalist who could lead a sing-song with the best of them. He enjoyed jokes (hearing them and telling them), with a particular penchant for the more ribald type. Vasari also portrays him as caring and tender-hearted. 'Leonardo's disposition,' he wrote, 'was so lovable that he commanded everyone's affection.' He was, for instance, friends with Bernardo Rucellai (who married into the Medici clan and hosted meetings of the Platonic Academy), the philosopher Marsilio Ficino, his fellow artists the de Predis brothers, and the writers Antonio Cammelli and Bernardo Bellincioni, to name just a few.

Yet over his lifetime, da Vinci established very few long-lasting and meaningful close relationships. He had an inherent distrust of people, the origins of which are clearly to be found in the failure of those on whom he should have been able to rely the most – his mother and father – to provide him with the emotional and pastoral support he needed in infancy. Having been monumentally let down by them, he was in no hurry to entrust his emotions to anyone else. It is a pattern perhaps reflected in his regular relocation from one city state to another, his inclination to call time on relationships and even his tendency to leave professional commissions incomplete. On one hand, we may read these characteristics as signs of a restless spirit with a constant desire for the new; on the other hand, they suggest a certain phobia of commitment.

Therefore, we may count on just a few fingers those relationships that demanded serious emotional investment. It is fair to argue that Tommaso Masini (otherwise known as Zoroastro) came into this category. Masini (who it has been suggested may have been the illegitimate son of Bernardo Rucellai) became da Vinci's assistant during his first period in Florence. He subsequently travelled to Milan and back to Florence with da Vinci, and assisted him in many notable projects, providing intellectual and creative succour as well as practical assistance. It is reputed he played a key role in da Vinci's flying experiments and may also have influenced his adoption of vegetarianism. Zoroastro had a reputation as something of an experimentalist, making curious concoctions and dabbling in alchemy. Certainly, he intrigued da Vinci,

drawing his attention to new areas of interest so that their friendship withstood the test of time.

However, the two most significant relationships in the adult life of da Vinci were with other members of his studio – Francesco Melzi and Giovanni Giacomo di Pietro Caprotti, or, as he was better known, Salai. These individuals came to be nothing less than da Vinci's surrogate family. Of the two, Melzi was the relative latecomer. Born in Milan into the aristocracy, Melzi became da Vinci's personal secretary in 1507. Intelligent, good-looking, sincere and urbane, he kept a close eye on da Vinci's personal affairs and helped him organize his copious notes. The two quickly became close confidantes and Melzi's genuine affection for his master shone through after da Vinci's death. The artist had entrusted him to curate his life's creative output and Melzi took on the role of literary executor with gusto. He worked tirelessly to bring some order to da Vinci's chaotic notebooks and kept alive the flame of the artist's memory, not least through gestures such as overseeing the posthumous publication of da Vinci's *Treatise on Painting*.

Where Melzi brought a semblance of calm into da Vinci's life, Salai swept through it like a whirlwind. Indeed da Vinci nicknamed him Salai, which means 'imp' or 'little devil'. Salai arrived as a ten-year-old in da Vinci's studio in 1490 and immediately made his mark. He was employed to provide general help with a view to later taking up a formal apprenticeship. After only a day in service, Salai stole the money that da Vinci had put aside to pay for new clothes for his most recent recruit. The master

annotated his diary entry that day with the words 'thief, liar, obstinate, greedy'. It set a pattern of misbehaviour by Salai that went on for decades, involving everything from brawling to cutting up the clothes of his enemies.

While he doubtless caused exasperation, there was something about the devil-may-care boy that charmed da Vinci. Perhaps da Vinci saw his own 'outsider' status reflected in his protégé. Salai also proved himself a highly competent artist over the ensuing years and became a valued member of the studio, even if he continued to wreak havoc and attract trouble. Salai and da Vinci would remain in each other's company for fully twenty-eight years, quite the longest association of da Vinci's life. When he died, the master left the apprentice a generous bequest in recognition of the younger man's 'good and kind services'.

So it was that an alchemist, a secretary of noble birth and a scamp broke down the emotional barriers that da Vinci had carefully constructed.

Forbidden Love in Renaissance Italy

'The bat, owing to unbridled lust, observes no universal rule in pairing, but males with males and females with females pair promiscuously, as it may happen.'

LEONARDO DA VINCI, WRITING
IN HIS NOTEBOOKS

We cannot categorically say that da Vinci was homosexual, but the circumstantial evidence argues strongly that this was the case. Take, for instance, the series of undeniably homoerotic drawings he produced, including the graphic *Angelo Incarnato* (*Angel in the Flesh*), complete with erection. Nonetheless, we cannot definitively say he was gay for the simple reason that da Vinci left us no confirmation of such. It was rarely in an individual's interests to advertise their homosexuality in the fifteenth or sixteenth centuries, so this is hardly surprising. Some scholars have gone as far as to suggest that he simply opted out of a sex life, living a sort of asexual existence. The quote opposite does indicate, however, that he saw homosexuality reflected in nature. Given the esteem in which he held the natural world, such observations may have been pivotal in his reconciling himself to a sexual persuasion that wider society decreed was unnatural.

Da Vinci's notes and scribblings point to a mind that recognized lust as a life force but nonetheless remained slightly nervous of its repercussions. He once wrote, 'Lust is the cause of generation. Appetite is the support of life.' Yet on another occasion he stated, 'The man who does

not restrain wantonness allies himself with beasts.' Desire may thus be seen as at once giving life but diminishing humanity's elevated status. His own parents' lack of a marriage (possibly in the face of their genuine love) furthermore undermined his sense that long-term sexual/romantic relationships pointed the way forward.

Homosexuality was not uncommon in Renaissance Italy, and was particularly widespread in the aristocratic and cultural milieu that da Vinci inhabited for most of his life. Nonetheless, it was officially condemned by both Church and state and anyone found guilty of participating in homosexual acts faced an uncertain future. Even if the odd dalliance of the rich and powerful might have been overlooked, the masses were given a clear message that to be gay was to be beyond the pale. Under Church law, sodomy was an act punishable by burning at the stake – a potent threat even if one rarely carried out. Between 1430 and 1505, about 2000 Florentines were 'convicted' of being homosexual. Some of those were indeed executed, but even those who were not endured everything from public haranguing and fines to branding and exile.

As to when da Vinci had his sexual awakening, again we can only speculate. Several historians have convincingly posited that da Vinci's master, Verrocchio, may have taken him as a lover. It is probable that da Vinci posed for him in 1466 for a striking sculpture in bronze of David. While it is a crude oversimplification to suggest that the artist–model relationship was destined to end in sexual congress, Verrocchio nonetheless had before him a fine-figured young man (a description confirmed by several

contemporary biographers) who was to some degree under his influence. Vasari would claim that Verrocchio 'loved' another of his pupils, Lorenzo di Credi, more than Leonardo (while the sexual undertones are not blatant, it does not take much to read them into Vasari's words). Nonetheless, it does not seem beyond the bounds of possibility that da Vinci and Verrocchio did have a physical relationship.

Some ten years after the statue of David was completed, the question of da Vinci's sexuality was being discussed in the public sphere. At that time, Florence ran a system in which a series of 'drums' (called *buchi della verità* or holes of truth) were located around the city. Citizens could deposit messages within these drums, providing the authorities with intelligence or making accusations against fellow city-dwellers. In 1476, an anonymous missive accused 'Lionardo di San Piero da Vinci, living with Andrea del Verrocchio' and three other men of scandalously consorting with a seventeen-year-old, Jacopo Saltarelli, who 'pursues many immoral activities and consents to satisfy those persons who request such sinful things from him'.

The accusation must have been like a bombshell going off in da Vinci's life. Not only was his name thrust into a public scandal at the hands of a nameless gossip, but he also faced scrutiny from the city authorities. After several anxious weeks' wait, he and his fellow accused were summoned to court on 7 June. Almost immediately the case was formally dropped, possibly after intervention from the Medici who would have been keen to avert

a public scandal since one of da Vinci's co-defendants, Leonardo Tornabuoni, had married into the ruling family. Even so, da Vinci seems to have spent a short spell in prison (perhaps only a few hours awaiting the hearing) that made a great impact on him. He would later write that freedom is 'the chiefest gift of Nature' and made drawings of a device designed to rip bars from a window or 'open a prison from the inside'.

Having had one narrow escape, he did not stay controversy-free for long. Just three years later, and by now master of his own studio, an air of scandal descended upon him again. In 1479, Paolo de Leonardo de Vinci da Firenze (probably one of Leonardo's apprentices and not, as the designation might suggest, his son) was evicted from the city to serve six months' detention elsewhere. The punishment came on the orders of Lorenzo de' Medici no less. His crime was not specified beyond his living a 'wicked life' – likely shorthand for being gay – and he was further condemned for keeping bad company in Florence. Might it be that da Vinci himself was considered part of this 'bad company'? Were the authorities sending a message to da Vinci – someone repeatedly depicted by his biographers as outré and flamboyant – that he needed to rein himself in?

There is also a drawing that da Vinci made around this time of a handsome young man. The dedication beneath it suggests it is of one Fioravante di Domenico, described as 'my most beloved friend'. Alas, vital parts of the dedication are illegible but several notable da Vinci scholars have speculated that this may have been

another boyfriend. It is also thought eminently possible that both Salai and Francesco Melzi became lovers of da Vinci. Just as da Vinci was considered statuesque and pretty, so too were these two assistants. The former, for instance, was described by Vasari as being 'extraordinarily graceful and attractive', with 'beautiful hair, curled and ringletted, in which Leonardo delighted'. The sexual tension is almost palpable. It is likely, too, that Salai was the model for *Angelo Incarnato*. Da Vinci must have held Salai in the highest affection to put up with his assistant's regular lapses into bad behaviour. To imagine that their love was all encompassing hardly requires a vast leap of the imagination.

Intriguingly, there is also evidence that, if read in a particular way, points to da Vinci having experimented with heterosexuality in his later years. In a list of names of associates he made around 1509, da Vinci includes that of a woman called Cremona. Who was she? The likeliest explanation is that she was a model for him. And in common with many of the female artist's models of the age, she may also have plied her trade as a prostitute.

As the *Mona Lisa* and other of his great portraits attest, da Vinci was able to relate to – one might even say love – women without lusting after them. His greatest paintings reveal an adoration and an extraordinary understanding of the female psyche. But da Vinci was not only interested in depicting women of high social standing or in the guise of the Virgin Mother. Although they no longer exist, we have plentiful reports of a remarkable rendering he made of the mythological tale of Leda and the Swan, in

which Leda is ravished by the creature. Meanwhile, in the Hermitage Museum in St Petersburg is a copy (reputedly by Salai) of a portrait that da Vinci made which appears to be a version of the *Mona Lisa*, only bare-breasted. It is possible – though by no means beyond doubt – that Cremona may have been the model for these rather raunchier depictions of femininity.

Furthermore, there is speculation that da Vinci was himself intimately acquainted with her. After all, here was a man who believed that knowledge stemmed from experience. He may have desired sexual knowledge of a woman to satisfy his own lust (that he was predominantly homosexual does not, of course, rule out the possibility that he had heterosexual urges). Or perhaps he wished to *know* a woman simply to expand his knowledge of the world or to inform his work – factors not to be underestimated in da Vinci's mind.

Da Vinci's sexuality is far from an open book but nor is it entirely closed. By looking at the weight of evidence, we may make certain assumptions about his orientation and the conduct of his personal life – considerations that dramatically impacted the course of his life and the practice of his work.

Get the da Vinci Look

'He was very attractive, well proportioned,
graceful and good-looking.'

THE ANONIMO GADDIANO, c. 1542

What did Leonardo da Vinci look like? It is a question that has fascinated art historians for centuries. By analysis of accepted and alleged portraits and self-portraits, along with testimony from near-contemporary biographies, it is possible to draw an impression.

The most common reimagining of da Vinci tends to have him as an elderly, bearded gent, almost wizard-like, his features gnarled by the weight of his own genius. We can put this popular image down to the existence of three hugely influential depictions. Firstly, a portrait of da Vinci in profile, rendered in red chalk by Melzi when da Vinci was around sixty years of age. Secondly, a purported self-portrait (a suggestion not universally accepted), housed in the Biblioteca Reale in Turin and dating to around 1510 (when da Vinci was only in his late fifties and surely looked younger than the man in the picture). And finally, Raphael's painting of Plato in the famous *School of Athens* fresco in the Vatican. Dating to around the same time as the Turin portrait, Raphael used several fellow Renaissance artists as models for the ancient Greek philosophers, with da Vinci widely accepted as the subject upon whom Plato is based.

But this impression of da Vinci as old, grizzled and world-weary tells only half the story. There is much other evidence to suggest that as a younger man, da Vinci was notably good-looking and dressed in an uncommonly flamboyant style. Furthermore, he almost certainly did not have any facial hair until he was in his fifties. The young da Vinci was, it might be said, something of a metrosexual.

His biographers are virtually unanimous that he was blessed with good looks. Vasari referred to his 'infinite grace', while the contemporary chronicler Paolo Giovio noted his 'extraordinarily beautiful' face, and Jean Lamaire de Belges (a writer at the court of Louis XII) was struck by his 'supernatural grace'. The Anonimo Gaddiano manuscript, meanwhile, stated: 'He was very attractive, well proportioned, graceful and good-looking' with curly hair , 'carefully styled', which cascaded down to his chest. We know da Vinci was a keen walker and horseman so it is not so surprising that he is also described as athletic, with Vasari going as far as to suggest he could bend a horseshoe with his bare hands.

This all chimes with the suggestion that da Vinci was deemed a suitable model for Verrocchio's sculpture of David and possibly also for the angel in the painting, *Tobias and the Angel*. There is also convincing – though not indisputable – evidence that da Vinci may have incorporated his own image into several works, including the face of *Vitruvian Man*, the figure at the far right of *The Adoration of the Magi* (1481), and perhaps even the *Portrait of a Musician* (1490).

It is also said that he went to considerable effort to

make the best of himself. He had, for instance, a beauty regime that included moisturizing with rose water and lavender. He also took the opportunity to belittle the generic sculptor whose face is covered in dust 'like a baker', comparing him to a painter well dressed and wearing the clothes 'he fancies'. The clothes da Vinci apparently fancied set him apart from the crowd. As the Anonimo Gaddiano describes it: 'He wore a short, rose-pink tunic, knee-length at a time when most people wore long gowns.' In addition, he sported fur-lined coats, boots made of the finest Cordova leather, and rings of jasper.

There were two distinct da Vincis, then: the youthful version who was something of a foppish man about town; and the older version whose beauty had been weathered by experience. Both are striking images representing a timeless icon.

Be Inspired by Professional Rivalries

'Leonardo and Michelangelo strongly
disliked each other ...'

GIORGIO VASARI IN *LIVES OF THE ARTISTS*, 1568

It is fair to say that da Vinci liked to be in charge of his professional life. However, he was not averse to establishing professional alliances. The life of the Renaissance artist was necessarily a collaborative one. Rarely was a completed work done by the master alone without help from his students.

Then there were wider collaborations, such as the one that saw da Vinci join forces with the de Predis brothers on pieces as notable as *The Virgin of the Rocks*. And there were the looser affiliations that saw artists (and in da Vinci's case, scientists, musicians, writers and philosophers) meeting together to socialize and exchange ideas. Da Vinci was blessed to be born into a time and place where he could potentially call upon the talents and mine the experience of some of the greatest artists not only of the Renaissance but of all time. Michelangelo was among his contemporaries, and Botticelli was also still active. Yet da Vinci did not forge a partnership with either of them (or the other great name of the age, Raphael). Instead, he was notably critical of each. His fellow 'greats' inspired him by igniting his sense of professional rivalry, not through any desire to yoke their extraordinary talents together.

Be Inspired by Professional Rivalries

Da Vinci was notably ungenerous when it came to complimenting fellow artists. His master Verrocchio, for instance, hardly garners a mention in his writings, despite the two ostensibly having got on well. His fellow apprentices – up-and-coming stars whom he saw on a day-to-day basis – received much the same treatment. That early Renaissance great, Giotto, was one of the few to receive a kind word, principally for not being content to mimic the works of his master but to take his lead from the natural world. No doubt Giotto was ripe for respect partly because he was long dead and no possible threat to da Vinci's own standing.

Sandro Botticelli (born 1445) was much more harshly treated. An apprentice of Fra Filippo Lippi (and also influenced by the draughtsmanship skills of Verrocchio), he helped plot the direction of Renaissance art in works such as *Primavera* (*c.* 1482) and *The Birth of Venus* (*c.* mid-1480s). Yet da Vinci dismissed his landscapes as dull, uninspired and unrealistic. Even as Botticelli was winning his reputation as a game-changer, da Vinci appeared to be putting him on the scrapheap.

Da Vinci saved his greatest professional resentment for Michelangelo. Michelangelo was almost a quarter of a century younger than da Vinci and, during the latter's period in Milan, became the rising star of Florentine art. In personality and disposition, they were virtual opposites. Where da Vinci had humble beginnings, Michelangelo was well born; and while da Vinci was gentle and charming in his everyday affairs, Michelangelo was abrupt and abrasive. Furthermore, Michelangelo did not much like the fact

that da Vinci tended towards the belief that painting was a higher art form than sculpture. By the age of twenty-five, let it be remembered, Michelangelo had completed his *Pietà* (in St Peter's Basilica in Rome), wringing from a slab of stone a level of emotion arguably unprecedented in the history of art.

Michelangelo and da Vinci probably had their first meeting in Florence in around 1500 or 1501. By 1505, da Vinci was sitting on a committee charged with deciding where to position Michelangelo's remarkable statue of David. Da Vinci, the records show, suggested it should be erected not on the main Palazzo Vecchio but in the Loggia dei Lanzi 'behind the low wall where the soldiers line up. It should be put there, with suitable ornaments, in such a way that it does not interfere with the ceremonies of state.' It was an uncomplimentary position to adopt, not to say highly mischievous. Da Vinci's fit of pique may have been heightened by the fact that he had previously modelled for Verrocchio's own sculpture of the great biblical king and he was doubtless not keen to see his image superseded by this interloper statue.

Da Vinci managed to get his own back on Michelangelo over time. On one occasion, for instance, he critiqued artists who produce figures with bodies like a 'sack of walnuts' – a not very heavily disguised slight against Michelangelo who went in for particularly muscular physiques. That Raphael (born 1483) was broadly tolerated by da Vinci may well have owed more to the fact that Raphael was an even greater nemesis of Michelangelo than da Vinci, rather than to any nobler feelings of professional respect.

(Raphael also showed the heavy influence of da Vinci in his work, which may have protected him from more vitriolic attacks.)

PICK YOUR FIGHTS CAREFULLY

The sixteenth-century manuscript, the Anonimo Gaddiano, described a public spat between da Vinci and Michelangelo. An argument broke out when da Vinci was discussing the works of Dante in a public square. A question of interpretation came up and he is said to have suggested that his companions consult Michelangelo, who just happened to be passing. Michelangelo, sensing some kind of attack on him, saw red and hit back with a diatribe against da Vinci, describing him as the man 'who designed a horse to cast in bronze, and couldn't cast it, and abandoned it out of shame'. Da Vinci was left shaken by the onslaught that specifically referenced the ill-fated Sforza horse.

It tells us much about the characters of da Vinci, Michelangelo and Raphael (and, perhaps, human nature in general) that these members of the great Renaissance triumvirate could not put aside personal rivalries in favour

of collaboration. One might only imagine what they might have achieved by joining forces. However, we should not underestimate the role that rivalry and competition played in pushing each of them to new heights. At times it might even have launched them into the realms of over-ambition, but there are worst crimes than that. For the rest of us, it is a luxury that we can enjoy them all.

THE BATTLE OF ANGHIARI

'It would be impossible to express the inventiveness of Leonardo's design ... not to mention the incredible skill he demonstrated in the shape and features of the horses, which Leonardo, better than any other master, created.'

GIORGIO VASARI IN *LIVES OF THE ARTISTS*, 1568

The Battle of Anghiari was a fresco that da Vinci was commissioned to paint in 1504 on one wall of the Salone dei Cinquecento (Hall of Five Hundred) in Florence's town hall. It was a large-scale and highly prestigious commission and, although the work has not survived (as far as we know), there is little doubt that – even unfinished – it rated as one of his finest works. But the story of da Vinci's *Battle of Anghiari* is given extra spice thanks to the fact that the city authorities had the vision to commission Michelangelo to paint a rival fresco on the opposite wall of the chamber.

Be Inspired by Professional Rivalries

Although in the event these two stellar names both failed to deliver completed works, their preparatory work (and in da Vinci's case, copies of the finished parts of the fresco) point to the fact that their personal rivalry inspired them to new levels of ambition and artistic excellence. As fate would have it, the Salone has also bequeathed us one of art history's most enduring mysteries.

Da Vinci's painting (the largest he would ever undertake, and for which he ordered bespoke scaffolding) was meant to celebrate a famous victory that Florence achieved over her Milanese rivals in 1440. However, da Vinci envisaged something other than a jingoistic celebration of Florentine valour. By this time he had seen at first-hand the horrors of the battlefield during his travels with Cesare Borgia's forces. He planned to produce an anti-war painting, which we might now perceive as the visual equivalent of Wilfred Owen's great poem, 'Dulce et decorum est'.

Da Vinci chose to depict a scene in which four horsemen fought to claim a standard. We can see from the cartoons he produced that he wanted to evoke a visceral tension behind the apparently heroic struggle. Alas for da Vinci, the project was hit by difficulties from the outset. Despite the problems he experienced on *The Last Supper*, he again refused to paint his fresco in the traditional manner. Instead he took the unprecedented decision to paint with oils directly on to the wall. Amid unfavourable climactic conditions, the different-coloured oils started to mix into one another. In a bid to speed up the drying process, he employed heaters but the oils dried at different rates on different areas of the wall. While the lower portions of

the painting dried nicely, the upper portions became a blotchy mess. Da Vinci's technical experiment had failed dismally.

No doubt crestfallen by the missed opportunity to eclipse his greatest professional rival, da Vinci ceased working on the scene in 1506. Michelangelo, meanwhile, fared little better. Depicting the Battle of Cascina, fought between troops from Florence and Pisa in 1364, his original cartoon was apparently a thing of wonder until (according to Vasari) it was defaced by a jealous rival artist, Bartolommeo Bandinelli. Just as da Vinci gave up on the commission, so did Michelangelo when he was summoned to Rome to work on the tomb of Pope Julius II. Today we have little more than a few of Michelangelo's preparatory sketches to point us towards what the completed work might have looked like.

The city authorities found themselves not with a hall adorned by masterpieces from each of the two greatest artists on the planet but instead one incomplete Michelangelo and one unfinished and significantly flawed da Vinci. The grand aspirations of these two men, pitched against each other in a 'Clash of the Titans', ended in disappointing underachievement. An object lesson in not overreaching for the sake of one-upmanship.

However, the story does not quite end there. Some fifty years or so after the two men had abandoned their works, Giorgio Vasari (the very same who served as biographer to the artists of the age) was given the job of redecorating the hall and the works of the two great masters were lost. As the years passed, the reputation of both of the original

battle scenes grew. In da Vinci's case, an early seventeenth-century work by Peter Paul Rubens, *The Battle of the Standard*, based on a mid-sixteenth-century engraving of da Vinci's work by Lorenzo Zacchia, helped consolidate the legend.

Then in the 1970s an Italian art historian called Maurizio Seracini speculated that *The Battle of Anghiari* may lay hidden beneath Vasari's over-decoration. For one thing, he did not believe that Vasari – the Renaissance curator extraordinaire – would have simply destroyed a work by da Vinci that, for all its flaws, was regarded as quite brilliant. Then there was an intriguing artistic flourish that Vasari had included in his own work, *The Battle of Marciano*: a soldier holds a flag inscribed '*Cerca, trova*' ('He who seeks, finds'). Was Vasari encouraging the viewer to look at the walls a little more closely? Structural surveys suggest that Vasari may have bricked over da Vinci's work to preserve it, and then painted on to the brickwork. So far, forensic investigations have proved inconclusive but hope remains that one day da Vinci's biggest (albeit compromised) masterpiece may see the light of day again.

Fight Your Corner: Da Vinci, the Military Engineer

'As the variety of circumstances dictate, I will make an infinite number of items for attack and defence.'

LEONARDO DA VINCI'S LETTER OF
INTRODUCTION TO LUDOVICO SFORZA,
EARLY 1480S

In Renaissance Italy, as in the world now, there was much money to be made from war. If you could devise new ways by which your master could defeat his enemy, you could expect riches and an elevated social position. It is disappointing that the figurehead of one of history's great intellectual bloomings should have plied his trade as an arms-maker and trader, but for a while that is just what da Vinci did.

He first started seriously touting himself in this role in the early 1480s. The letter that da Vinci drafted to Sforza while in Milan saw him make 'bold, without ill-will to any, to offer my skills to Your Excellency, and to acquaint Your Lordship with my secrets'. Da Vinci elaborated that he had 'methods for making very light and strong bridges, easily portable', 'methods for destroying any fortress or redoubt even if it is founded upon solid rock', could manufacture 'certain types of cannon, extremely easy to carry', had 'ways of silently making underground tunnels and secret winding passages to arrive at a desired point', and had conceived 'armoured cars, totally unassailable'. 'Where bombardments turn out to be impractical,' he went on, 'I will devise catapults, mangonels [a type of

siege engine], caltrops [a device made out of spikes of metal], and other wonderfully effective machines not in common use'.

As a brilliant inventor and designer, da Vinci did indeed have plans for everything he described. However, he had no demonstrable track record as a working military engineer. It is a measure of the confidence he possessed in his abilities that he felt able to make up for the shortfall in hands-on experience with the power of his imagination. Furthermore, Florence was full to bursting with arsenals and armouries at this time, supplying hardware for the regular skirmishes with neighbouring cities, so at least da Vinci had the opportunity to see up close how the business operated.

The designs he produced over several years proved his self-belief was not misplaced. His underlying philosophy was to take existing machinery of war and make it simpler and more effective. Among his many inventions were the armoured car proposed above (something that looks rather like a flying saucer in his drawings), a giant crossbow, a chariot with protruding blades to cut down the oncoming enemy, an early attempt at a machine gun that could fire thirty-three rounds in rapid succession, a steam-powered cannon and a stealth-attack vessel complete with black sails to help it evade detection. Arguably most incredible of all were his plans for what we today recognize as a submarine, which he described thus:

By means of a certain machine many people may stay some time under water. I do not describe my

method of remaining under water ... and I do not publish nor divulge these by reason of the evil nature of men who would use them for assassinations at the bottom of the sea, by sending ships to the bottom and sinking them together with the men in them.

Had da Vinci entertained but a brief dalliance with the arms-making game, it may be easier to overlook it as an anomaly in his career. However, in 1502 – at a time when he was arguably at the peak of his powers and fame – he left Florence for Rome, where he took up employment with Cesare Borgia. Borgia was the illegitimate son of Pope Alexander VI, who shamelessly did everything in his power to further the careers of his children. Cesare himself was utterly ruthless (he was accused, for instance, of murdering his own brother) and clever with it – indeed, Machiavelli used him as the model for that ultimate study in pragmatic power, *The Prince*. Irreligious, immoral, pragmatic, decisive and merciless, he was one in a series of 'strong man' figures to whom da Vinci was drawn. Channelling Freud for a moment, we may even wonder whether da Vinci embraced the macho business of weapons-making to impress these substitute father-figures.

It is also possible, though so far unprovable, that da Vinci joined Borgia's camp at the urging of the Florentine authorities. Borgia had been throwing his weight around middle Italy, taking various cities, appointing himself Duke of Romagna in 1501 and effectively handing Florence an ultimatum: accept me as a friend or suffer me as an enemy. With da Vinci working as his military engineer, Borgia could mine his expertise while the Florentines got a man

on the inside who could keep them abreast of Borgia's intentions. It would be a satisfying explanation for da Vinci's apparent willingness to join forces with a warmonger of such ill repute. It was while working for Borgia, it is worth noting, that da Vinci struck up his friendship with Machiavelli, then a young Florentine diplomat.

As well as designing machinery of war, da Vinci was sent on a tour of Romagna to inspect fortifications and advise on engineering projects. Borgia even granted him a passport so that 'our most excellent and well-beloved architect and general engineer' could survey 'the places and fortresses of our states'. Among the largest projects he took on was the construction of fortifications at Cesena and Porto Cesenatico on the Adriatic. For much of the time he was travelling with Borgia's troops, living the life of a military man. It must have been an eye-opening experience for someone more used to the *bottegas* of Florence and Milan. Yet even as he immersed himself in military life, his notebooks show that he was always open to more innocent distractions, from the topography of an area new to him to the bespoke mechanism of a church bell. The intellectual magpie was as hungry as ever to mine his experiences to the maximum.

Nor was Borgia the unstoppable force that for a while he seemed to be. Once his father died in 1503 and he could no longer claim papal support, his grip on power began to slip. Within four years he would be dead, slaughtered in an ambush. Long before then, da Vinci seems to have detected which way the wind was blowing and, along with Salai and Zoroastro, left the duke's service.

It is difficult to be sure which of da Vinci's military designs were manufactured and which remained only as ambitious ideas. We do know, however, that he was once more far ahead of the game, imagining weapons – machine guns, submarines, armoured cars – that would not be fully realized for centuries.

DA VINCI'S LIGHT AND DARK

'A most beastly madness.'

LEONARDO DA VINCI ON WAR

Da Vinci's forays into military engineering represent one of the great enigmas of his life. How could this peace-loving man – who liked to free the birds on sale in his local market – prostitute himself to those intent on mass destruction?

Part of the reason was doubtless simple pragmatism. Da Vinci was always in need of money and this was an effective way to get it. In the interests of his account book, he seems to have been able to distance himself from the ethical aspect of this work. It is difficult to imagine him dwelling too long on the damage his creations might cause as he put his pen to paper, laying down blueprints that are aesthetically pleasing even as the machines they depict are terrifying. In the same way, he was able to design sets for public spectacles (and in the case of Ludovico Sforza, a series of proposed political emblems) that were stunning to behold without necessarily aligning himself with the

politics of the patrons that they promoted. Whether such expediency is to be admired is difficult to say.

There is another factor to consider in relation to his military designs. Da Vinci was a man in whom light and dark coexisted in close proximity. Like most of us, he was prone to mood swings, his psyche an ongoing battlefield upon which purity of intention and darkness of thought fought for dominance. Indeed, it was a conflict he successfully mined in his work. In the late 1480s, for instance, he produced a series of allegorical works that drew links between pain and pleasure, and envy and virtue. Then there are his renderings of grotesques and his caricatures of elderly subjects (the reworking of one of these drawings is familiar to many modern readers as John Tenniel's illustration of the Queen of Hearts for Lewis Carroll's *Alice's Adventures in Wonderland*) to set against the great beauty of *Vitruvian Man*, *Lady with an Ermine* or *The Virgin of the Rocks*. He portrayed life as a dichotomy between beauty and ugliness, light and shade, the divine and the worldly, pleasure and pain, innocence and experience, good and bad.

Let us not forget that it is in his exploration of the grey area between light and dark that da Vinci made some of his most important technical innovations in painting. His *sfumato* effect, for example, blends shadows and highlights seamlessly into one another. He intended to write a series of no less than seven books on the subject of light and shadow, 'the most certain means by which the shape of any body comes to be known'.

We can trust that da Vinci genuinely considered war

a 'beastly kind of madness'. We need only think of *The Battle of Anghiari* or the notes he wrote while in Milan on how to represent a battle:

> First you must show the smoke of the artillery, mingling in the air with the dust thrown up by the movement of horses and soldiers ... If you show one who has fallen you must show the place where his body has slithered in the blood-stained dust and mud ... Others must be represented in the agonies of death, grinding their teeth, rolling their eyes, with their fists clenched against their bodies and their legs contorted ... There might be seen a number of men fallen in a heap over a dead horse.

Yet he also realized that war was a natural part of existence, the inevitable consequence of the foibles of man. He could not stop it, so why should he not reap some benefit from it? Life, as da Vinci understood it, was always about the delicate balance between light and dark.

Eat Like
da Vinci

'Do not eat when you have no appetite
and dine lightly.'

LEONARDO DA VINCI, WRITING
IN HIS NOTEBOOKS

Leonardo da Vinci's greatness resulted from his passionate interest in pretty much everything. So it should come as little surprise that he was fascinated by food, cookery and nutrition. In an era when most people lived hand-to-mouth on what they could grow themselves, while the rich mindlessly feasted and gorged with little thought for the consequences, this set him apart from the norm.

Gastronomy was a passion evident throughout his notebooks, in which he kept detailed lists of foods he had seen on his travels (along with their prices) as well as shopping lists for himself and his household. He was, in addition, employed by Ludovico Sforza in Milan to help design opulent banquets. Inevitably, da Vinci would have kept an eagle eye on the proposed menus. He was also charged with redesigning the duke's kitchens in 1482, which allowed him to indulge his passion for gadgetry. He invented, among other things, a device that used heat from a fire to assist in turning meat on a spit.

A note in the Codex Atlantica provides an intriguing insight into his plans for the duke's refit:

The large room for the retainers should be away from the kitchen, so the master of the house may not hear their clatter. And let the kitchen be convenient for washing the pewter so it may not be seen carried through the house ... The larder, woodstore, kitchen, chicken-coop, and servants' hall should be adjoining, for convenience. And the garden, stable, and manure-heaps should also be adjoining ... Food from the kitchen may be served through wide, low windows, or on tables that turn on swivels ... The window of the kitchen should be in front of the buttery (pantry) so that firewood can be taken in.

While Sforza and his chums filled their bellies with such delicacies as saffron risotto with duck and mushrooms, da Vinci's tastes were simpler. For one thing, he suffered significant illness as an adult and believed sensible eating was vital to maintaining good health. Consider the regimen, below, that he documented in 1515:

If you want to be healthy observe this regime.
Do not eat when you have no appetite and dine lightly,
Chew well, and whatever you take into you
Should be well-cooked and of simple ingredients.
He who takes medicine is ill advised
Beware anger and avoid stuffy air.
Stay standing a while when you get up from a meal.
Make sure you do not sleep at midday.
Let your wine be mixed with water, take little at a time

Eat Like da Vinci

Not between meals, nor on an empty stomach.
Neither delay nor prolong your visit to the toilet.
If you take exercise, let it not be too strenuous.
Do not lie with your stomach upward and your head
Downward. Be well covered at night,
And rest your head and keep your mind cheerful.
Avoid wantonness and keep to this diet.

It is also considered probable that da Vinci was a vegetarian. Not only was this a rarity in the Renaissance period, but it was regarded with nothing less than suspicion by the authorities. Whether it was a lifestyle choice driven by personal taste, health considerations or compassion for animals, we may only wonder. Early biographies suggest da Vinci could not abide cruelty to animals, but nor was he a sentimentalist. For example, he once wrote:

Why did nature not ordain that one animal should not live by the death of another? Nature is more ready and more swift in her creating than time in his destruction; and so she has ordained that many animals shall be food for others.

For da Vinci meat was not murder so much as part of the cycle of life. But while he included meat on several of his shopping lists, it is likely that this was reserved for his household. We do know, on the other hand, that the Italian explorer Andrea Corsali once wrote to Giuliano de' Medici of his travels in India: 'Certain infidels called Guzzarati are so gentle that they do not feed on anything

which has blood, nor will they allow anyone to hurt any living thing, like our Leonardo da Vinci.' Certainly, it would not be a great surprise to find that da Vinci was a step ahead of his age in his food preferences.

He was the proud owner of just a single cookbook but nonetheless a very notable one – Platina's *On Right Pleasure and Good Health*, published in 1470 and widely regarded as the first printed cookbook. Da Vinci invented some recipes of his own too, including a salad dressing, and he had a particular taste for chickpea soup, almond pudding, fried figs and beans.

According to his records, he kept a well-stocked larder, replete with buttermilk, eggs, fruits, vegetables and pulses. He also maintained a reasonable stock of wine, although he was somewhat conservative in this. 'Wine is good, but water is preferable at table,' he insisted. For many, da Vinci counts as a dream dinner-party guest. The conversation would no doubt be scintillating. Whether the food and drink would live up to the same standards is less certain.

Keep a Note
of It

'His writing conveyed his ideas so precisely, that his arguments and reasonings confounded the most formidable critics.'

GIORGIO VASARI IN *LIVES OF THE ARTISTS*, 1568

Like the *Mona Lisa*, da Vinci is an enigmatic figure, with the biographies written closest to his own time being variable in their reliability. However, he did bequeath us an extraordinary insight into his ideas and personality in the form of the many notebooks he so assiduously filled over a period of decades.

He started keeping his notebooks in earnest from the late 1490s while he was resident in Milan, although there is a significant body of text that predates this. It is thought he filled at least 13,000 pages over his lifetime (some estimates suggest a much higher figure) of which some 6,000 to 7,000 are still known to exist. This includes some twenty-five complete notebooks. Da Vinci tended to use notebooks covered in vellum (calf-skin) and fastened with a wooden toggle.

Among the most significant collections of his notes are the following:

- The Codex Arundel, held by the British Library in London.
- The Codex Atlanticus, compiled in the late sixteenth century by artist and book-lover Pompeo Leoni, housed at the Biblioteca Ambrosiana in Milan.

- The Codex on the Flight of Birds at the Biblioteca Reale in Turin.
- The Codex Leicester, in the collection of Bill Gates in Seattle.
- The Codex Trivulzianus at Milan's Biblioteca d'Arte del Castello Sforzesco.
- The Codex Urbinas (Treatise on Painting) in the Vatican's Biblioteca Apostolica Vaticana.
- The Forster Codices, held by London's Victoria and Albert Museum.
- The Madrid Codices, discovered at the Biblioteca Nacional in Madrid in 1966 quite by chance. The most recently found of da Vinci's manuscripts, they maintain hope that others may follow.
- The Windsor Castle Codex, in the Royal Library at Windsor in the UK.
- Twelve manuscripts (identified by the letters A to M) are held by the Institut de France in Paris.

So what was da Vinci's motivation for keeping notes? His mind was a constant whirl of ideas across such a spectrum of subjects that his notebooks helped him to organize these thoughts (although as the body of work expanded, their lack of organization became almost suffocating). The notebooks allowed him the opportunity to revisit ideas that might otherwise have dissolved into the ether as each new train of thought muscled its way into his consciousness. He also no doubt hoped that Sforza, his master in Milan, would be able to see that the reach of his work made him an indispensable member of his court.

In broader terms, da Vinci envisaged that he would eventually compile his notes into a comprehensive encyclopaedia of everything – the ultimate book of knowledge for the Renaissance world and a worthy successor to the great works of the ancients, like Pliny the Elder's all-embracing *Naturalis historia*. In commenting on his own writing, da Vinci was modest, although we can assume his sometimes self-effacing tone was laced with irony. He reflected, for example:

> Seeing that I can find no subject specially useful or pleasing – since the men who have come before me have taken for their own every useful or necessary theme – I must do like one who, being poor, comes last to the fair, and can find no other way of providing himself than by taking all the things already seen by other buyers, and not taken but refused by reason of their lesser value. I, then, will load my humble pack with this despised and rejected merchandise, the refuse of so many buyers and will go about to distribute it, not indeed in great cities, but in the poorer towns, taking such a price as the wares that I offer may be worth.

Yet da Vinci knew – how could he not? – that his work was not only important but groundbreaking. He was not peddling second-hand wares but proffering ideas and insights wholly original to him. The following extract is a better indication of da Vinci's truer feelings towards his writings:

I know that many will call this useless work, and they will be those that Demetrius declared that he took no more account of than the wind that came out of their mouths in words, than of that they expelled from their lower parts: men who desire nothing but material riches and are absolutely devoid of that of wisdom which is the food and the only true riches of the mind. For so much more worthy as the soul is than the body.

The contents of his notebooks are extraordinary by any standards. The topics he covered included aerodynamics, anatomy, architecture, botany, costume design, civil and military engineering, fossils, hydrography, mathematics, mechanics, optics, philosophy, robotics, astronomy, stage design, viticulture and zoology. There are intricate scientific drawings, plans for proposed inventions, beautiful artistic studies, rough doodles, jokes, poems, riddles, fables, draft letters, accounts, recipes, shopping lists, cast lists, bank statements, notes of addresses ... if you can think of it, you could probably find an example of it. Not a scrap of it is without value. Even the most apparently trivial jotting gives us an intriguing peak into da Vinci's everyday life. Then there are those extracts that represent great scientific leaps forward (some of which we are still only beginning to appreciate all these centuries later) or provide invaluable insights into his artistic mastery.

Yet, as so often in his life, the sheer scope of da Vinci's ambition was ultimately his undoing. Even as he dreamed of synthesizing these notes into a taut, logical multi-

volume 'book of wonder', the task was beyond him. The subsequent dissipation of the notebooks means it is a job that will never be completed.

Da Vinci began the task of seriously arranging his notebooks around 1507 but by then he already knew his chances of success were slim. 'I fear that before I have completed this,' he wrote, 'I shall have repeated the same thing several times, for which do not blame me, reader, because the subjects are many and the memory cannot retain them and say, This I will not write because I have already written it.' But even as he struggled to gain control of the notes already compiled, he continued to add to them. In his later years he carried out some of his most important work in anatomy, embryology and geometry, all of which found its way into his notebooks, alongside new ideas on old favourite themes including water and flight.

The last known entry he made is a rather touching one in which he breaks off from a mathematical discussion when his maid calls him to come and have his soup, which 'is getting cold'. It is a fitting epigraph to his writings, as the humdrum mundanities of everyday life interrupt his cerebral gymnastics for the very last time.

After da Vinci died, the thankless task of bringing some order to the notes fell to his companion, Melzi. He did a fine job considering the size of the challenge and was responsible for compiling the still influential *Libro di Pittura* (*Treatise on Painting*) that was eventually published around the time of his own death in 1570. Alas, Melzi's son Orazio and his descendants were less diligent and many of da Vinci's writings subsequently went missing, either lost,

sold or given away. Others were, unforgivably, stolen – most infamously by the nineteenth-century Italian count and literary kleptomaniac, Guglielmo Libri, who grossly abused his role as Chief Inspector of French Libraries.

Da Vinci's notebooks – incomplete and elusive as they are – represent nothing less than a cultural wonder of the world and are every bit as important as the *Mona Lisa* or *The Last Supper* when trying to understand him as an artist, intellect and human being.

MIRROR WRITING

'He wrote in letters of an ill-shaped character, which he made with the left hand, backwards; and whoever is not practised in reading them cannot understand them, since they are not to be read save with a mirror.'

GIORGIO VASARI IN *LIVES OF THE ARTISTS*, 1568

One of the most instantly striking aspects of da Vinci's notebooks is that they are largely written in mirror writing. With a few exceptions where he made notes clearly intended to be easily read by someone else, he wrote in a script that sweeps from right to left across the page, with every word and every letter within them inscribed backwards. The only way to read the script is to hold it up to a mirror.

Mirror writing is a phenomenon that scientists are still trying to unpick, in order to understand how the

brain achieves it and why. Da Vinci is one of the very few exponents, and by far the most famous, in all history. The question why he wrote like this is at the heart of a debate that rages to this day.

There is a camp that argues that da Vinci's writing reflects his self-education. In his lifetime, left-handedness was regarded with great suspicion (the Latin for 'left' is *sinister*). Most left-handed children who were sent to school simply had the habit crushed out of them. They had no choice but to learn to write right-handed or suffer the consequences. The young Leonardo, however, had a rudimentary education in which this 'failing' (as it was undoubtedly seen) was not addressed. So the argument goes that in teaching himself to write, Leonardo simply hit upon this technique as being easier for him, avoiding the inevitable ink blots a left-hander experiences when writing from left to right.

Others, however, suggest there is a more sinister (I use the word advisedly) aspect to the mirror writing: namely, to preserve the secrets of his texts from prying eyes. As we know, some of the contents of the notebooks were incendiary by the standards of the day, and might have brought the opprobrium of the Church down upon him. Furthermore, da Vinci was fiercely protective of his intellectual property and may have believed his mirror writing served as some kind of security.

Alas, it is unlikely that we will ever know for sure why he employed the system. It is nonetheless evidence of his extraordinary brain, physiologically adapted so as to be capable of writing in a manner that is beyond most of the rest of us.

Da Vinci
and God

'I leave alone the sacred books for they are
supreme truth.'

LEONARDO DA VINCI, WRITING
IN HIS NOTEBOOKS

What was Leonardo da Vinci's relationship with God? In recent years the question has come under renewed scrutiny thanks to *The Da Vinci Code*. Let us not spend any more time discussing that particular tome, save to say that those who believe its narrative is rooted in fact see da Vinci not merely as a holder of heterodox Christian belief but as the guardian of a divine secret that demands a fundamental re-evaluation of the nature of man and God.

A rather more sober suggestion is that da Vinci was broadly a believer in Roman Catholic teachings, but one who was prepared to examine Church doctrine and quietly held certain unorthodox beliefs. As the quotation on page 189 indicates, da Vinci never openly questioned the existence of God. Growing up in fifteenth-century Italy, it would have been shocking if he had not adhered in general terms to the dominant Catholic faith. It would have been more than his life was worth (not to mention professional suicide) to have openly cast doubt on the Church's fundamental teachings but there is little firm evidence that he harboured such doubts anyway. It is

reasonably safe to assume that da Vinci believed in 'the basics' such as the Holy Trinity of Father, Son and Holy Spirit, and the existence of heaven and hell.

That is not to say that he had a very easy relationship with the Church. Artists have historically served as society's renegades, questioning received wisdom and proposing alternative ideas. The Renaissance, meanwhile, increasingly demanded empirical evidence. Faith was still a vital component of society, but blind faith was losing its footing. The Church, nonetheless, demanded complete subjugation from its believers. Conflict was inevitable.

As the Renaissance brought forth artists and academics with newly enquiring minds, so elements of the Church responded by taking a hard line. Hence the rise of figures like Girolamo Savonarola, who briefly stepped into the void created in Florence by the declining fortunes of the Medici at the end of the fifteenth century. A fire-and-brimstone preacher, he represented a turn towards fundamentalism, ruthlessly condemning sins of the flesh, preaching moral purification and actively promoting the destruction of artworks – most famously in the 1497 Bonfire of the Vanities, when his supporters burned thousands of cultural objects (from make-up to books and paintings) in a huge conflagration.

Alongside this, da Vinci's personal circumstances and professional conduct brought him into several collisions with Church authorities, so that he became something of an outsider figure. At the heart of this conflict was da Vinci's probable homosexuality. His sexual proclivities not only ruled out honest acceptance into the heart of

the Church but put his mortal soul at risk. In 1484, for instance, Pope Innocent VIII issued a papal bull, *Summis desiderantes affectibus*, which equated homosexuality with witchcraft and led to widespread persecution of gay men and women, resulting in deaths and excommunications. Da Vinci thus spent his life as a Church outlaw.

These tensions were only accentuated by his sporadic contractual run-ins with the Church. His move to Milan came amid an unedifying falling out with the monks of San Donato a Scopeto who had commissioned *The Adoration of the Magi* and were distraught that da Vinci had not finished it. Then there was his denunciation to the Pope by parties unknown in relation to his dissection work. In particular, his work on embryos was controversial. Da Vinci eventually came to believe that a mother and her unborn baby shared life in such a way that if the pregnant mother died, there was not a separate soul of the baby to be saved. Given the Church's belief in the sanctity of life from the womb onwards, da Vinci was asking for trouble by evolving such an avant-garde belief.

Da Vinci also had a streak of irreverence to the point of iconoclasm. It is conceivable that his disputes with Church authorities made him only more irreverent. Regardless, his work could be as challenging to a fifteenth- or sixteenth-century Roman Catholic as it was awe-inspiring. Here was a man who trampled on centuries of Christian iconographic tradition. Where once pictures had served primarily as aides-memoires to stories from the scriptures, da Vinci imbued them with emotional intensity. He depicted saints without haloes,

while his representations of angels and the Virgin Mother expressed a hitherto unexplored sexuality.

Then there is the John of *The Last Supper*, who may easily pass for a woman, and his various renderings of John the Baptist. The latter was by custom usually shown as a gaunt figure, reduced by living on locusts and honey in the desert. Yet da Vinci painted him with almost womanly curves and a smile reminiscent of the *Mona Lisa*. John is reimagined as an androgynous figure with a resemblance to Dionysus, the Greek god of wine and fertility. To mention nothing of the suggestive *Angelo Incarnato*. This was provocative art and no mistake.

Da Vinci also harboured grave disappointment in mankind as a whole, which does not sit well with the orthodox belief that man represents the summit of God's creation. Consider this observation: 'It will seem as though nature should extinguish the human race, for it will be useless to the world and will bring destruction to all created things.' Such was da Vinci's respect for nature that we might even wonder if he was not more comfortable with a proto-pantheistic view of religion. Vasari wrote of da Vinci's life in 1550: 'He had a very heretical state of mind. He could not be content with any kind of religion at all, considering himself in all things much more a philosopher than a Christian.'

Intriguingly, this observation was deleted from later editions of the work, with Vasari instead depicting da Vinci as a flawed but essentially good Roman Catholic. Realizing that his life may not have been always pleasing to God and the Church, Vasari has him making a deathbed

about-turn:'feeling that he was near to death he earnestly resolved to learn about the doctrines of the Catholic faith and of the good and holy Christian religion. Then, lamenting bitterly, he confessed and repented.' This, after all, was the artist Vasari described as 'marvellous and divinely inspired'.

There is evidence that da Vinci did indeed strive to make his way back towards the bosom of the Church. In October 1515 he applied to join the Confraternity of St John of the Florentines. His motives, though, are not clear. Was this a genuine late religious blooming or was he perhaps hedging his bets to protect his prospects in the afterlife? Perhaps he simply hoped for some help with potential funeral costs, something with which he knew the Confraternity was duty-bound to assist. Rather comically, he was soon threatened with expulsion from the order after failing to pay his fees – possibly a simple oversight as he prepared to make a new life in France.

It serves as a suitably ambiguous note on which to end an analysis of da Vinci's relationship with God. Suffice to say, da Vinci was a Catholic who was not so much lapsed as severely flawed in the eyes of the authorities. However, that he came into conflict with God's representative on Earth does not, as history has shown time and again, necessarily mean he was a less godly person than those who judged him.

A Question
of Legacy

'Not only was he esteemed during his lifetime
but his reputation endured and became even
greater after his death.'

GIORGIO VASARI IN *LIVES OF THE ARTISTS*, 1568

Whatever his precise religious beliefs, Leonardo da Vinci harboured fears about death and uncertainty about what would happen to his soul. He viewed death in unromantic terms, as part of a grand cycle of life and renewal in which the individual was but a tiny – and insignificant – element. He wrote: 'Our life is made by the death of others. In dead matter insensible life remains, which, reunited to the stomachs of living beings, resumes life, both sensual and intellectual.'

Regardless of his ultimate celestial fate, he seemed convinced that death would be a painful experience, stating: 'Whatever it is, the soul is a divine thing. Therefore leave it to dwell in its works, and be at ease there ... for it takes its leave of the body very unwillingly, and indeed I believe that its grief and pain are not without cause.' This uncertainty as to what lay ahead undoubtedly informed his desire to leave a lasting mark on the world.

Time and its passage also troubled him, its elusive nature causing him to ponder in the Codex Atlanticus: 'Things that happened many years ago often seem close and nearby to the present, and many things that happened recently seem as ancient as the bygone days of youth.' His

notebooks taken as a whole reveal a strikingly changeable attitude to the passing of time, prompting him to swing between optimism and despair. At times he was bullish, as when writing: 'Men are in error when they lament the flight of time, accusing it of being too swift, and not perceiving that it is sufficient as it passes; but good memory with which nature has endowed us, causes things long past to seem present.'

But elsewhere he is unable to see past time as an enemy, preventing him from meeting all his challenges or reaching the unfeasibly high standards he set himself. In these moments, time presented only a path towards death and decay: 'O Time! Consumer of all things; O envious age! Thou dost destroy all things and devour all things with the relentless teeth of years, little by little in a slow death.' This notion of time as a devourer of life and energy was one he would revisit with some regularity, as in the following passage: 'This is the supreme folly of man – that he stints himself now so he will not have to stint later, and his life flies away before he can enjoy the good things he has laboured so much to acquire.'

His fear that the sands of time were running out inevitably grew as the years advanced, and all the more so as he succumbed to ill health. It is thought likely, for instance, that da Vinci suffered a serious deterioration of his eyesight in old age, an affliction it has been said that he tried to remedy by wearing spectacles of his own design. A loss of vision is a terrible experience for anyone but we can only wonder how it impacted the psyche of da Vinci, whose whole life had revolved around seeing things in

a way others could not. It must have been akin to the desperation Beethoven felt as he began to go deaf. The following extract from da Vinci's notes gives some idea of just how his declining powers filled him with dread:

The eye whereby the beauty of the world is reflected is of such excellence that whoso consents to its loss deprives himself of the representation of all the works of nature. The soul is content to stay imprisoned in the human body because thanks to our eyes we can see these things; for through the eyes all the various things of nature are represented to the soul. Whoso loses his eyes leaves his soul in a dark prison without hope of ever again seeing the sun, light of all the world; How many there are to whom the darkness of night is hateful though it is of but short duration; what would they do if such darkness were to be their companion for life?

There is also significant evidence that he suffered a stroke towards the end of his life (probably in 1517) that caused paralysis in his right hand. While this did not prevent him from working altogether (since he was left-handed), it would have seriously curtailed what he could achieve and no doubt refocused his thoughts on his own mortality. Da Vinci lived to a good age for the time, but that meant he had ample opportunity to consider just what his life's work amounted to. The thought of all those unfinished projects – from the Sforza horse and *The Battle of Anghiari* to the unrealized dream of flying and the chaotic volumes

of notes that he had not managed to put in order – doubtless gnawed away at him. 'When I thought I was learning to live, I was learning to die,' da Vinci wrote in the Codex Atlanticus, his eyes once again turned to the spectre of death.

Towards the end of 1516 he made the decision to leave for France at the behest of Francis I. It was the longest journey he ever undertook but the rewards were significant, including a pension and residency in a manor house at Cloux, near Amboise in the Loire Valley. In return, the king did not ask much of his guest beyond regular audiences, since he delighted in da Vinci's company. Francis considered that there was no greater mind alive in the world. It was a judgement with which few could argue.

Yet da Vinci, blighted by failing eyesight and unable to use his right hand, refused to stop working. While he could no longer paint to the level he demanded, he nonetheless continued to draw and write. He also carried on with his studies, requesting, for instance, a large tome on the formation of the human body in the womb, along with the works of the great thirteenth-century scholar and philosopher, Roger Bacon. While continuing his own education, he kept up his teaching, too, and pursued his fascination with flight and water.

As of 1517, he was working on a new palace complex for the king near Amboise, complete with an elaborate canal system. Perhaps fittingly, it was another grand da Vinci scheme that never came to fruition, existing only as a dream on paper. He remained sociable, too, hosting

parties that became famous for flamboyant gimmicks including a triumphal arch and re-enactments of sieges and battles. In June 1518 he held a party in honour of the king himself, an event that must be considered da Vinci's last known work. To the end he was determined to make an impression.

The end itself came on 2 May 1519. According to Vasari, he passed away in the presence of Francis, although this was probably a literary flourish on the part of the biographer. 'Every hurt leaves a displeasure in the memory,' da Vinci had once written, 'except for the supreme hurt, which is death, which kills the memory together with life.' As we know, however, he need not have feared disappearing from our collective memory. Nor was he forgotten by those who had known him best in life. Take, for example, the heartfelt eulogy of his companion, Melzi: 'He was like the best of fathers to me. As long as I have breath in my body I shall feel the sadness, for all time. He gave me every day the proofs of his most passionate and ardent affection.'

In his will, da Vinci was generous and thoughtful. To his maid, he left a fur coat. To his brothers, a sum of money, possibly in settlement of an old debt. To Salai, some property and his paintings, including the *Mona Lisa*. And to Melzi his technical equipment, drawings and manuscripts. Melzi was effectively charged with keeping alive the flame of his master's memory – a job he carried out passionately and efficiently for the rest of his life.

Da Vinci did not die as financially rich as he might have done and left but a small circle of people who could really

claim to know him. His body of work, meanwhile, was both awesome in its quality and scope, but frustrating in some of the promise that it failed to deliver. One suspects nobody felt the frustration more acutely than he. But his was not a life wasted in any respect. While the burgeoning fame of the likes of Raphael and Michelangelo perhaps left him doubtful of his place in the pecking order of his own era, time has delivered him enduring fame beyond them all. 'As a day well spent procures a happy sleep,' da Vinci had once mused, 'so a life well employed procures a happy death.' That was surely his just desserts.

I began this book by commenting that da Vinci is now often conjured up to serve as little more than a cipher for a particular period in history, for art in general and for the notion of genius. Yet for those who wish to dig a little deeper, da Vinci the likeable, big-hearted, troubled, complex man remains to be rediscovered – from his extant artworks, his own copious notes and the stories that others have woven around his life. Vasari never doubted da Vinci's legacy, even as he acknowledged his shortcomings: 'And because of his many wonderful gifts (although he accomplished far more in words than in deeds) his name and fame will never be extinguished.'

That great chronicler of art history of more recent vintage, Kenneth Clark, viewed da Vinci as a great icon on whom we reflect our own thoughts, ideas and impressions. 'Leonardo is the Hamlet of art history,' he memorably said, 'whom each of us must recreate for himself.' It is true that da Vinci's 'meaning' evolves over time, but even as the terms of reference change, the flame that da Vinci passed

on to Melzi continues to burn. The last word should, of course, go to Leonardo da Vinci himself:

Observe the flame of a candle and consider its beauty. Blink your eye and look at it again. What you see now was not there before, and what was there before is not there now.

Selected
Bibliography

Bortolon, Liana, *The Life, Times and Art of Leonardo*, Crescent Books (1965)

Bramly, Serge (translated by Sian Reynolds), *Leonardo: The Artist and the Man*, Michael Joseph (1992)

Clark, Kenneth, *Leonardo da Vinci*, Penguin (1976)

Cremante, Simona, *Leonardo da Vinci: The Complete Works*, David & Charles (2006)

DeWitt, Dave, *Da Vinci's Kitchen: A Secret History of Italian Cuisine*, BenBella Books (2007)

Dickens, Emma (ed.), *The da Vinci Notebooks*, Profile Books (2005)

Freud, Sigmund, *Leonardo da Vinci and a Memory of His Childhood*, Amereon (1965)

Giovio, Paolo, *Notable Men and Women of Our Time*, Harvard University Press (2013)

Kemp, Martin, *Leonardo*, Oxford University Press (2011)

McCurdy, Edward, *The Mind of Leonardo da Vinci*, Cape (1952)

Nicholl, Charles, *Leonardo da Vinci: The Flights of the Mind*, Penguin (2005)

Shlain, Leonard, *Leonardo's Brain: Understanding da Vinci's Creative Genius*, The Lyons Press (2014)

Vasari, Giorgio (translated by George Bull), *The Lives of the Artists*, Penguin (1965)

White, Michael, *Leonardo da Vinci: The First Scientist*, Abacus (2001)